ELIOT PORTER

Vanishing Songbirds

The Sixth Order
Wood Warblers and Other
Passerine Birds

INTRODUCTION
AND BIRD NOTES BY
KENN KAUFMAN

BULFINCH PRESS
LITTLE, BROWN AND COMPANY
BOSTON • NEW YORK • TORONTO • LONDON

A Constance Sullivan Book

FIRST EDITION

LIBRARY OF CONGRESS CATALOGING-IN-PUBLICATION DATA

Porter, Eliot, 1901–1990

Vanishing songbirds : the sixth order : wood warblers and other passerine birds / Eliot Porter :
introduction and bird notes by Kenn Kaufman.

p. cm.

ISBN 0–8212–2225–2

1. Songbirds — North America — Pictorial works. 2. Rare birds — North America —
Pictorial works. 3. Photography of birds — North America. I. Kaufman, Kenn. II. Title.

QL696.P2P867 1996

598.8'097–DC20 96–24484

CIP

Bulfinch Press is an imprint of Little, Brown and Company (Inc.)

Published simultaneously in Canada by Little, Brown & Company (Canada) Limited

PRINTED IN ITALY

Contents

The Sixth Order

Wood Warblers and Other Passerine Birds

ELIOT PORTER

MY FASCINATION with birds began in my early childhood, when I was about eight years old. I still remember how excited I was when I found their nests in bushes and trees around our house in Hubbard Woods, a suburb of Chicago. About the same time, I was given my first camera, a box Brownie, but photography did not become a special interest until several years later.

In 1911 my father built a house on an island off the coast of Maine, and beginning in 1913 we started going there every summer. The large seabirds on the coast of Maine were a new experience. Gulls and terns nested in colonies on small, grass-covered islets, where the eider ducks also built their nests of down; and ospreys built their large stick nests on nearby rocky headlands.

Photography then became a major activity, and when I was given an Eastman Kodak camera, I began to spend many hours photographing the downy young gulls and ospreys from a blind that I set up next to their nests. My Kodak, which had a shutter speed of only 1/150 of a second, was not adequate to photograph the birds landing on their nests. However, eventually I acquired a Graflex camera, also called a naturalist's camera, because it was the sine qua non for the wildlife photographer.

When I went to college, my interest in photographing birds waned. And it was not until I had graduated from medical school and was doing research in bacteriology at Harvard University that I bought a Leica – the first 35-mm camera made in Germany. I immediately began experimenting with it, photographing a great variety of subjects.

About this time I was invited to dinner by the sister of one of my boyhood friends, who lived in Cohasset, Massachusetts; having heard that I had taken up photography as a hobby, she asked me to bring some of my pictures, because she had invited another photographer. The other photographer turned out to be Ansel Adams. The experience of seeing Ansel Adams's photo-

graphs had a profound effect on me, and on his advice I got a larger camera to improve the quality of my photographs.

Shortly after this experience, I met Alfred Stieglitz at my brother Fairfield's apartment in New York City. Stieglitz suggested that I come to his gallery, An American Place, on Madison Avenue whenever I was in New York. Over a span of several years, I visited him periodically, bringing a selection of photographs for him to review and criticize. He was always very severe in his criticism and would tell me to work harder, that photography was not easy to do. Eventually, in the fall of 1938, he looked at the photographs I had brought, and after going through them twice, he said, "I want to show these." The exhibition at An American Place was for three weeks in December 1938 and January 1939. This event changed my life; I decided then that I was a better photographer than scientist and subsequently resigned my position at Harvard University.

After buying a 4 x 5 camera on the advice of Adams, I became more interested in photographing the small songbirds that nested in great variety on the island in Maine. I had been especially attracted by these small passerine birds, particularly the Wood Warblers, because of their colorful plumage and distinctive songs by which they are readily identified. My reason for wanting to photograph them was that I had seen in various journals photographs that could be considered only as ornithological records and that I thought were of poor quality. What I wanted to achieve were photographs of birds of a quality comparable to the photographs of Adams and Stieglitz, who had taught me that the entire image area is important if one's goal is the production of works of high aesthetic quality. I did not want simply to document birds, but to photograph them and their surroundings with equal clarity.

But I soon discovered that in the woodland and shady conditions in which these birds nested, it was possible to photograph them only at large apertures and slow shutter speeds, with the result that most parts of the subject were out of focus. To achieve my goal, I realized that I would have to devise a different method.

At that time, foil-filled flashbulbs had just become available. With a triggering device that synchronized the flash with the shutter, I photographed birds in Maine, and by carefully arranging the flashbulbs near the birds' nests, I was able to obtain photographs at top shutter speeds and small apertures. The result was that when the bird was not moving, everything in the picture was in focus. (Samuel Grimes of Jacksonville, Florida, was the only other photographer who used artificial light to photograph birds at that time.)

After I took a series of pictures with this new equipment, I sent some of the results to *Audubon* magazine. The editors were very interested in how I got the photographs. As I photographed more birds with artificial light, I decided I wanted to do a book on them and showed a collection to Paul Brooks, editor-in-chief at Houghton Mifflin. He complimented me on them but rejected the idea of a book on the grounds that birds could not be identified in black-and-white and, for publication, would have to be photographed in color. I am sure he had no concept of the problems photographing birds in color presented at that time.

Nevertheless, I took his advice as a sort of promise and began investigating color techniques. This made the process of bird photography even more complicated. Eastman Kodak Company had just developed Kodachrome film, which I immediately adopted for photographing birds in Maine. The early Kodachrome was a beautiful film but had a speed of only ASA 5 so that much larger apertures were necessary or flashbulbs had to be placed closer to the subject, which made photographing subjects as elusive as birds even more difficult.

I then went to Eastman Kodak in Rochester to find out how to use this film with flash, and they suggested using a blue filter, since flash light was too yellow for exposing Kodachrome, which was intended for exposure in daylight. Soon, however, blue-dyed flashbulbs became available in place of blue filters. Previously, when I had used flashbulbs with black-and-white film, I had used not only one, but two bulbs, positioned at angles, in order to make the lighting more natural. I continued with this technique when I began to use color film, but because of the slowness of the film, I either had to place the bulbs closer to the subjects or use a larger aperture. And I was also limited by having to use a top shutter speed of 1/250 of a second, which did not stop birds in motion.

Then one day I saw some pictures of stopped-motion photographs by Harold Edgerton of the Massachusetts Institute of Technology, who had invented stroboscopic flash. What especially attracted my attention was a photograph he had made of a hummingbird; it occurred to me that perhaps I could apply this technique to other birds, too.

When I went to see Edgerton, he gave me a wiring diagram for making this equipment. In stroboscopic photography the exposure was determined by the duration of the flash, which was less than 1/10,000 of a second and had to be synchronized with the shutter. I could set the shutter at the highest speed with a simple device that made contact when the shutter was open. However, I discovered that, for my specific needs, this device did not give off enough light;

I could not use small enough apertures to get the necessary depth of field for high-quality pictures of birds in their environments.

At that time there was a great deal of interest in electronic flash, and I wrote to Strobo Research in Milwaukee for information. I described what kind of pictures I wanted to make, and they built a special outfit for me that had more energy storage. With this new equipment, which included three flash lamps, I was then able to take pictures of birds with the lens set at the smallest aperture – f/45. Finally, with this device I could photograph small birds as they landed on their nests.

But one problem remained: with this equipment I had to trigger the shutter manually. I now had more efficient technical equipment, but my own reaction time had to be fast enough to take advantage of the efficiency of the equipment.

Shortly afterward, I saw a story in *Time* magazine about how Crawford Greenewalt, president of Dupont, photographed hummingbirds, and I wrote to him to find out how his exposures were controlled. He had a photoelectric triggering device whereby the bird, as it interrupted a light beam, triggered the camera, taking its own picture. Greenewalt generously sent me such a device to try, but I had difficulty adapting it to my equipment. When I returned it to him explaining the problem, he invited me to his home when I was next in the East. Soon after, I made arrangements to meet him at his office in Wilmington, Delaware, and he drove me out to his house, where he showed me his photographic equipment as well as his private machine shop.

During my stay, he showed me his apparatus for taking stopped-motion pictures of hummingbirds. It was a small, compact device that included a photoelectric cell that could be pointed at the sky or at a miniature light source. Interruption of the light beam by a bird triggered the shutter. When I asked how I could obtain such equipment, this machinest offered to make it for me in exchange for several of my prints. This equipment allowed me to photograph many species of birds in flight in their natural settings that I had not been able to photograph before. I could now decide more accurately when to take the photograph, as there was a remote-control device which permitted me to trigger the shutter or not, according to the situation.

I first used this equipment to photograph warblers (the passerines that interested me the most); my ambition was to photograph all fifty species that exist in the United States, and eventually I did photograph forty-four of them. I got to know their ranges and habitats from bird books and came to recognize their songs so that I could locate their nests. For many years, during springs especially, I photographed them in numerous different areas in the United States.

IN ADDITION to my interest in photographing passerines, I have always been intrigued by the adaptation and speciation of these birds, especially the warblers. During the ice age, which continued up to about ten thousand years ago, the North American continent, down into the central part of the United States, was largely covered by ice several thousand feet thick. Below the ice, the vegetation was generally tundra and arctic coniferous forests. At that time, the passerine birds were mainly confined to South and Central America, and if they migrated at all, it was only over short distances into the northern parts of Mexico and most southern parts of the United States. Only later, as the ice melted and environmental conditions changed, did the passerines begin to migrate farther north.

The speciation of one group of the wood warblers called Dendroica, which includes the Black-throated Green Warbler, the Black-throated Gray Warbler, the Townsend's Warbler, and the Hermit Warbler, is particularly interesting. As the ice retreated and the climate warmed, the ancestral species of these birds started migrating farther north, some going across the Gulf of Mexico to Florida and the East Coast, some to the Midwest, and others north of Mexico to Texas, the Southwest, and the Northwest. As they established their migratory roots, groups became genetically separated, and during that time they evolved diversification of plumage and song – character traits of adaptation to the environment. However, they retained enough shared behavioral characteristics to be traced to their common ancestry.

This evolutionary adaptation of the Dendroica also must apply to other genera of the wood warblers, and to groups of passerines such as flycatchers, thrushes, vireos, and sparrows. Undoubtedly, they, too, became more specialized as a result of adaptation to their habitats; and as they established migratory roots, adapting to their new environments, their plumage changed.

Now, with the advance of civilization and the occupation of the land for resource exploitation by humans, both the tropical and temperate (winter and summer) habitats of these birds are being altered and destroyed. For example, the deforestation of tropical rain forests has considerably affected the migratory bird population. At the same time, the use of synthetic pesticides, such as DDT, has not only destroyed the food supply of many birds but also poisoned the birds themselves.

Industrialization has had an equally destructive effect on the environment by producing acid rain, which is responsible for killing lichens, including the usnea lichen, which grows in hanging

masses in northern forests. Usnea lichen has, for example, almost completely disappeared in northern Michigan. Usnea lichen (or beard moss) is used by the Parula Warbler as exclusive nesting material; without it they may not be able to survive. Recently, a friend of mine reported finding the nest of a Parula Warbler built on the ground, where it was much more vulnerable to predation.

Even during the period of time I have been photographing the passerines, their number has conspicuously declined and they are often not found where they used to be plentiful – something we were warned about by Rachel Carson in her book *Silent Spring*. One purpose of this book is to call attention to the environmental effect of the activities of humankind – the effect that our destruction of natural resources is having on the passerine population.

Introduction

KENN KAUFMAN

IN COMPLEX PURSUITS like photography, it often happens that the pioneers concentrate on technical things. They lay the groundwork and develop the technique; it is left to later practitioners to raise the craft to an art. But it does not always turn out that way. Consider the field of bird photography, and the work of Eliot Porter showcased in this volume.

Porter was undoubtedly a pioneer. He was among the first to pursue serious color photography of birds, experimenting with new equipment and new films as soon as they were invented. Knowing that, one might open this book expecting quaint pictures with purely historical interest. But such an expectation would not last beyond the first page or two. Porter was not just an experimenter, but a consummate artist with a camera. He produced images of a quality seldom rivaled by any of the legions of bird photographers who came later.

Anyone can admire the beauty of these portraits and their glimpses into the home lives of songbirds at their nests. Someone who knows these birds well will admire something else: the sheer effort that went into acquiring these photos. For some of these birds, it is possible to put in hours or even days of search without ever finding a nest. Considering the effort and then the artistry that were required to produce this collection, we might conclude that Eliot Porter was somehow superhuman. But one suspects that Porter would have been impatient with this reaction. Probably he would have preferred that we be impressed by the birds themselves, as he was.

* * *

THIS COLLECTION is named *Vanishing Songbirds*, and both elements of the title are worthy of some background discussion. Taking the noun first, it seems like an arbitrary judgment call: are these birds all great songsters? Actually, "songbird" is just a convenient group term. Birds are classified into more than twenty separate orders, mostly distinguished by technical points of anatomy. The largest order, containing about half the bird species in the world, is the Passeriformes, the order of perching birds. Scientists call them "passerines" for short, but the typical

person has never heard that word. "Songbird" is more widely understood and is appropriate for the majority of the birds in this order.

As a group, these are the most familiar birds in most areas of the world. Eagles and condors and grouse are mainly wilderness creatures, remote from our everyday experience, but many songbirds live in our gardens and city parks: robins, goldfinches, buntings, orioles, jays, cardinals, and many more. They are popular and rightly so.

With over five thousand kinds found worldwide, generalizing about the songbirds is not easy. However, most are fairly small birds. Many are quite colorful. Most have songs that are pleasing to the human ear. In North America, many are migratory, traveling south in autumn and returning north in spring. Quite a few among these are long-distance migrants, leaving the United States entirely for the winter, even making long over-water flights to Central America, South America, or the West Indies.

In North America, the males of most kinds of songbirds are singing on mornings in spring and early summer, announcing their territorial claims. Each singer announces that this patch of woods, or this section of meadow, is where he and his mate will raise a nestful of young birds. The song warns other birds of the same species not to trespass. The bird's colorful pattern helps to underscore this territorial message, and helps him to attract a mate. So there are practical reasons, scientific reasons, for the color and music of the birds. But this does not in the least reduce their ability to brighten our lives.

Songbirds are rewarding at whatever level we choose to notice them. Some are obvious: goldfinches and cardinals visiting the windowsill to dine on seeds, an oriole flashing across the yard, robins caroling along city streets at dawn. Others are more elusive. The warblers, for example, are so small that the typical person may overlook them entirely. Yet warblers are tiny gems, active little birds with bright patterns and with wonderful variety: North America has more than fifty kinds. Small wonder that the warblers were among Eliot Porter's favorite subjects.

This collection, however, is to represent *vanishing* songbirds. The concept is alarming. Are we in the process of losing all of these birds? Are robins and cardinals really on their way out? No, fortunately, not all of these birds are declining. Many songbirds are still in healthy numbers, and a few are actually increasing. But many are indeed vanishing, far more than might be expected in the normally swaying balance of nature. Concern over this widespread trend toward lowered numbers was what inspired Eliot Porter to assemble this collection.

It would be reasonable to ask how we know that any of these birds are disappearing. Certainly no one has gone out to count all the birds one by one; that would be impossible in most cases. And a scientist would not trust general impressions – the sense, say, that the woods are quieter than they once were. So some might say (indeed, some have already said) that the decline of the songbirds is an unfounded theory. Unfortunately, it is not. We have good evidence for population trends for most of our birds.

Since the mid-1960s, thousands of volunteers have taken part in an annual census called the Breeding Bird Survey. Instead of trying to count every bird, it counts a representative sample. (The principle is the same as that of a public-opinion poll or a television-ratings system.) Hundreds of survey routes across the United States and southern Canada are censused every year: the same routes, by the same exacting method, at the same season. Bird totals on any one route may vary from year to year; but when a high percentage of the routes show the same trend (up or down), we may be certain that it represents a real change in bird populations. And for many of the songbirds, the survey results show a genuine trend downward.

A very different kind of evidence, based on high-technology monitoring, underlines the findings of the Breeding Bird Survey. Many migrating songbirds come north across the Gulf of Mexico every spring, crossing from the Yucatàn Peninsula to our Gulf Coast, and these myriads of little birds actually show up on weather radar in the coastal regions. In the 1960s, a scientist named Sidney Gauthreaux studied this phenomenon and worked out ways of getting rough estimates of bird numbers from the radar echoes. In the early 1990s he repeated the study and looked for changes in numbers. Gauthreaux found that there had been a definite and major drop in the numbers of migrant birds being picked up on the radar screens.

These two lines of evidence back up what many long-time bird watchers have said: songbirds, especially those that migrate long distances, are in shorter supply today than they were just a few decades ago. The kind of weather conditions that would have produced a major flight of migrants in the past now produces only a moderate or small passage, or sometimes none at all. Species that once sang in every woodlot are now heard infrequently. Some birds have been quietly fading away at the edges of their ranges.

Concerned by this bad news, conservationists have rallied to try to save the songbirds. But before their decline can be reversed, of course, the reasons for it must be understood.

The threats faced by our songbirds today are more complicated than the problems solved by

bird conservationists in the past. When egrets and other waders were declining drastically in the late nineteenth century, the reason was obvious: the birds were being slaughtered so their filmy plumes could be used in fashion. Simple protection from the killing was enough to start the egrets on the road to full recovery. No one today is actively killing the songbirds. They are being affected by more subtle and insidious factors, problems with no easy solutions.

Most of Eliot Porter's songbird photographs contain a hidden message – hidden because it is so clearly visible. The message is that a bird's environment is supremely important. These are not mere feather portraits, showing sharp birds against blurred backgrounds. Every leaf, every sprig of moss within the frame is in crisp focus. These are environmental portraits, reminding us that we cannot consider the bird without considering its surroundings. When our songbirds start disappearing, it means that things are out of balance in the total life-support system of the continent.

The most obvious threat to our songbirds is loss of their habitat. The majority of species are tied to particular habitat types, and they cannot thrive elsewhere. Furthermore, these habitats all have limits on their carrying capacity. A section of prairie or marsh or thicket can support only so many individual birds. If a square mile of forest is cut down, the birds there cannot simply move to another; that other forest, most likely, is already occupied.

Different habitat types in North America are being affected by different things. Marshes and swamps have been drained in many regions, converted to developments or farmland; songbirds that live in wet places (as well as ducks, rails, bitterns, and other aquatic fowl) are now far less numerous than they were historically. Certain kinds of meadows, thickets, and open woods were once maintained by the occasional wildfire that swept through. We cannot let fires go unchecked in settled areas, of course, but in our zeal to suppress all fires we have rendered some types of natural habitats rare, along with the birds that live there. In the southwestern deserts, and along streams through dry country, even limited amounts of grazing can cause long-term damage in some areas, as this seemingly rugged terrain proves to be unexpectedly fragile. Thus, many separate categories of birds are affected by habitat loss.

However, the songbirds that seem most seriously threatened are the migratory species of the eastern and northern forests. In the deciduous forest of the eastern United States, and in the mixed and coniferous forest that stretches across much of Canada and into central Alaska, live scores of species of small birds that migrate far south in winter – going to the southern states or to the tropics. It is among this category that we find most of the birds showing troublesome declines.

For birds that migrate to the tropics, loss of habitat on the wintering grounds may be just as critical as loss of nesting habitat. In fact, problems may be magnified there, both because the total land area is so limited and because the undisturbed tropical habitats can support so many individuals. Bird populations that are spread across vast areas of the United States and Canada in summer may be crammed into small sections of Central America in winter. Cutting down a few acres of tropical forest may eliminate the wintering grounds for songbirds that have come from many square miles of the north woods.

However, we cannot simply blame the problem on our neighbors to the south. For many birds, much of the decline can be traced to changes on their nesting ranges. Here, the total acreage left in forest can be a misleading number, because more and more often, the remaining forest is being broken into smaller pieces. Unfortunately, fragments of woodland are simply not as good for most birds. Ten plots of ten acres each will not support as many Red-eyed Vireos or Scarlet Tanagers as will one plot of one hundred acres. One of the drawbacks to small forest fragments is that they magnify the impact of an unlikely agent of destruction: another songbird species, the Brown-headed Cowbird.

Cowbirds are brood parasites. That is, they lay their eggs in the nests of other songbirds, and leave the unwitting foster parents to incubate the eggs and care for the young. The cowbird nestlings develop rapidly, demanding most of the food brought in by their "hosts," with the result that these foster parents often succeed in raising only the cowbirds and not their own offspring. Where cowbirds are common, they can seriously lower the reproduction of other species.

Centuries ago, Brown-headed Cowbirds were common mainly on the Great Plains. They were really "bisonbirds" then, following the herds around the prairie regions; probably they did not remain in one area long enough to hurt the local bird populations. Today, cowbirds are practically everywhere. Although they avoid the interior of dense forest, they will range into the edge of the woods; and as the forest becomes more fragmented, a higher percentage of it is close to the edge. By putting in roads and driveways and numerous other artificial clearings, we have made it easier for the cowbirds to find their victims.

Other threats to the larger ecosystems may also affect our songbird numbers. Even three decades after Rachel Carson warned of the possibility of a "silent spring," unwise use of pesticides continues in some areas. Acid rain, a direct result of air pollution, continues to damage forests, especially in the Northeast. And recently the spectre of global warming has been raised.

If it is real, if climate changes begin to occur on a measurable scale, then local habitats may change so rapidly that many songbirds will be unable to adapt.

So the problems facing our vanishing songbirds are complex ones, not to be solved overnight. Dealing with any of them will take imagination, and reasonable discussion, and compromise. We cannot simply padlock the woods and save them for songbirds alone. Human needs have to be met, of course. But in the long run, things that we do to benefit the birds should benefit mankind as well.

The situation is certainly not hopeless. Humans have met bigger challenges in the past. What is needed is the collective will to do something about the problem. Awareness is the first ingredient: awareness that leads to appreciation and concern. May this collection of exquisite portraits serve as a reminder of the wonderful diversity of life around us, diversity that we risk losing. May we take the necessary steps so that the songbirds will survive, not merely in Eliot Porter's magnificent photographs, but in our woods and fields, in our lives.

It seems almost too gaudy to be real, or at least too exotic
for this continent, but the Painted Bunting is actually rather common
in summer in parts of the Southeast. The winter range is mostly in the
Caribbean, Mexico, and Central America, but some stay through the season
in Florida, even visiting bird-feeders in a few lucky neighborhoods.
Typically this bunting stays low, in brushy thickets or the edges of woods,
but the male will sing from higher in trees. His more softly colored mate
stays out of sight. She does most of the work of tending the nest, eggs,
and young, hidden in dense bushes. Sadly, this beautiful bird has been
declining in numbers in recent decades. This may be partly because it is
still captured and kept as a cagebird on its tropical wintering grounds.
Another likely cause is pressure from cowbirds,
laying their eggs in the buntings' nests.

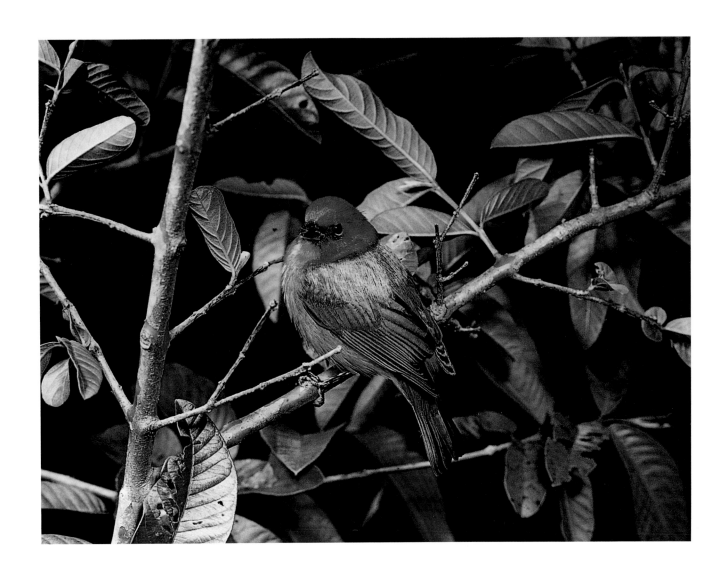

[1] PAINTED BUNTING

Passerina ciris

THREE KINDS of bluebirds live in North America,

but only the male Mountain Bluebird is ethereal sky-blue all over.

Fittingly, this is the member of the trio that lives closest to the sky,

in open mountain meadows or even on the slopes above timberline.

The female is a soft pale gray, with touches of blue. The summer range of

this bird extends from central Alaska south as far as southern New Mexico

and California. In winter, Mountain Bluebirds gather in flocks and wander

the West in search of fruiting junipers or other sources of berries.

When a hundred of these birds descend on a juniper grove,

pale blue and gray against dark green, their soft colors complemented

by low-pitched musical calls, they make an unforgettable sight.

Because they nest in holes in dead trees, Mountain Bluebirds may have

declined in some areas following the cutting of snags and

competition with Starlings for the remaining nest sites.

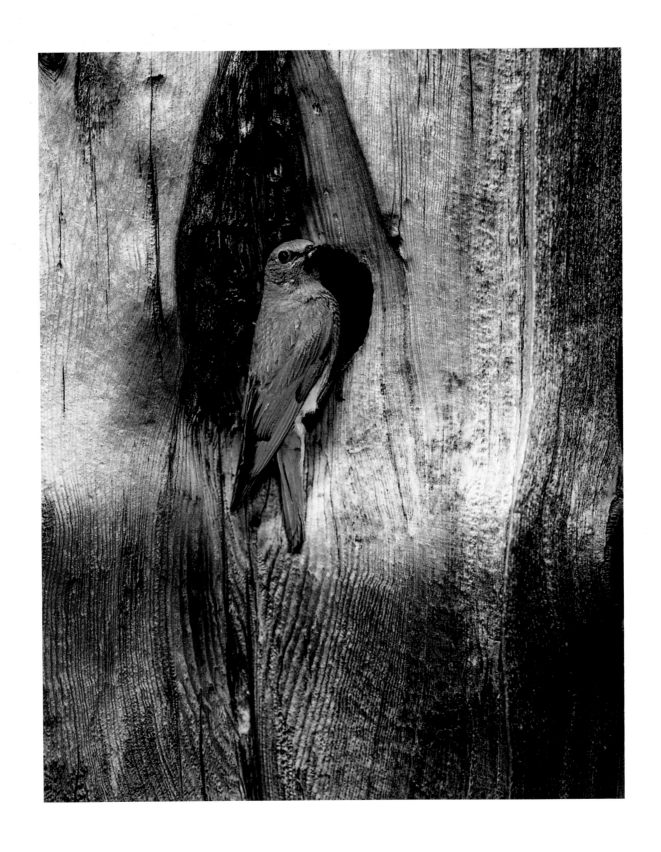

[2] MOUNTAIN BLUEBIRD

Sialia currucoides

ONE OF THE MOST popular of all birds in the East is the

Northern Cardinal. Chosen as the official state bird by no fewer than

seven eastern states, it lives in forests and swamps, suburbs and city parks,

readily coming to backyard bird-feeders to feast on seeds.

However, the range of this species also extends into the arid Southwest.

There it may be found in streamside thickets and along arroyos through

the desert, a far cry from its eastern haunts. The Arizona race of the cardinal

is a little larger and a paler, brighter red than the eastern bird,

but the difference is not obvious on casual inspection; its rich whistled song

sounds about the same everywhere. Arizona Cardinals place their nests

in dense shrubs, often among spiny tangles where

they will be safe from all predators.

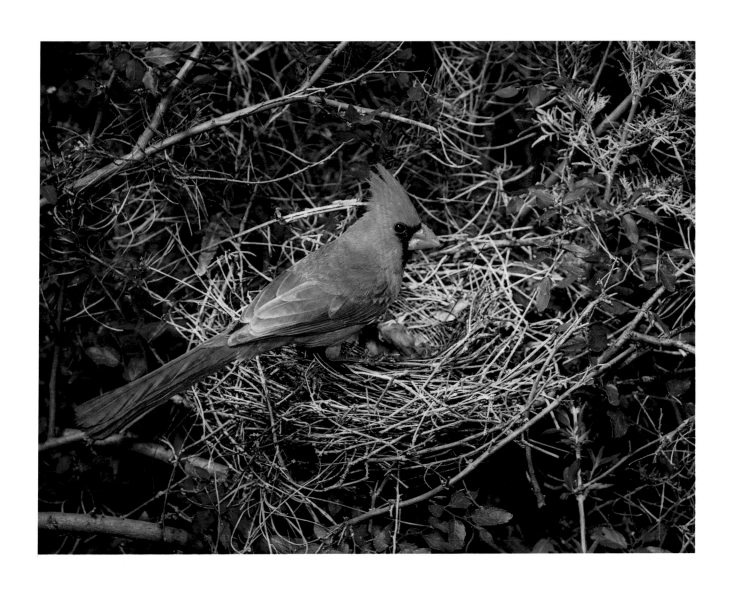

[3] ARIZONA CARDINAL

Cardinalis cardinalis superbus

A CLOSE RELATIVE of the cardinal, the Pyrrhuloxia is typical of
arid lands in the Southwest, from Texas to Arizona and south into Mexico.
Some would call it "Desert Cardinal," but this name could mislead:
cardinals themselves also dwell in the desert in some regions. There are places
near the Mexican border where the two species can be found side by side.
The female Pyrrhuloxia, shown here, looks much like a female cardinal,
but her bill is more rounded and is yellowish, not red. The male is mostly
a gray bird, with accents of red on his chest, wings, tail, and spiky crest.
Pyrrhuloxias build cup-shaped nests out of twigs and weeds,
hiding them in thorny shrubs. Although these birds do not migrate,
they will gather in flocks and range widely
over the countryside in winter.

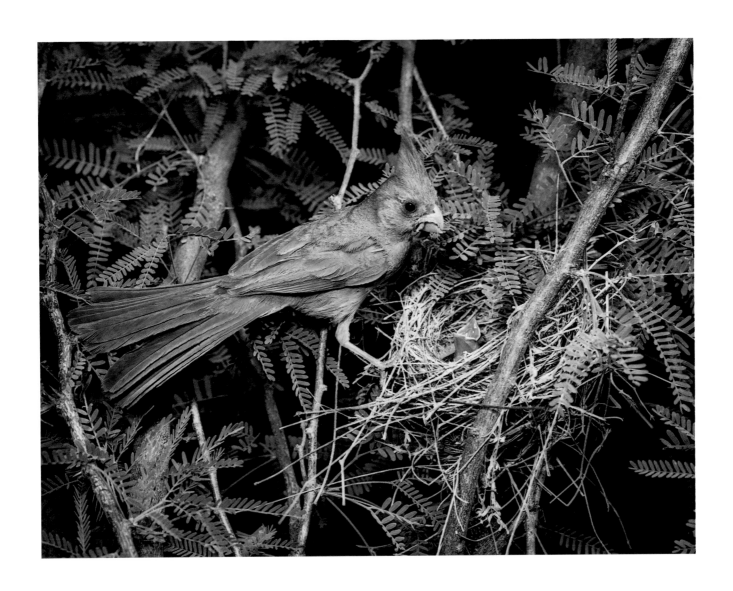

[4] PYRRHULOXIA

Cardinalis sinuatus

Soft in color and soft in voice, Cedar Waxwings seem
the gentlest of birds. They are sociable at most seasons, wandering in flocks,
seeking the berries that make up a major part of their diet. Some observers
have reported a charming habit: a line of waxwings perched side by side
on a twig will pass a berry back and forth, from bill to bill, until one of the
birds finally swallows it. Cedar Waxwings are found from coast to coast,
summering in southern Canada and the northern United States,
wintering in the South, with some flocks moving into the tropics.
Their numbers in a particular region may vary from one year to the next;
few may be seen in a year when drought reduces the crop of wild berries.
The nesting season for waxwings is usually in late summer,
later than for most songbirds, ensuring that a good supply of berries
will be ripe for the young birds.

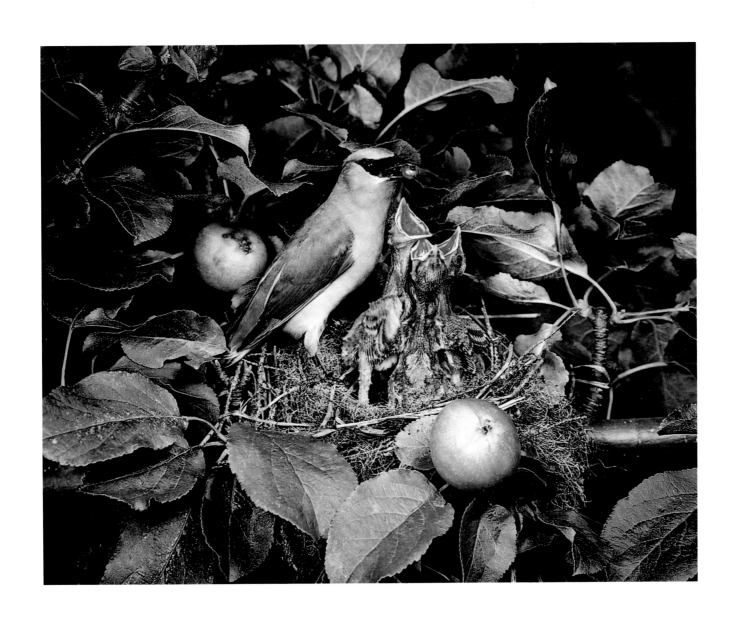

[5] CEDAR WAXWING

Bombycilla cedrorum

ONE OF THE most vexing mysteries facing conservationists today
is the disappearance of the Loggerhead Shrike from the Northeast. As recently
as the 1950s, this bird was still fairly widespread in the northeastern states in
summer, but its range has been steadily receding in the decades since.

No one knows exactly why. Some would blame changes in habitat,
although the shrike's usual haunts – open country with scattered trees and
bushes – still seem relatively easy to find. Others say that pesticides may be
the root of the problem: shrikes are predatory songbirds, feeding on large
insects and even other creatures as large as mice, and any poisons in the
ecosystem will tend to become concentrated in the bodies of predators.

Or some unknown factor may be involved. Whatever the reason,
the Loggerhead Shrike's gradual disappearing act has continued to this day,
presenting another challenge for those who work
to save our songbirds from extinction.

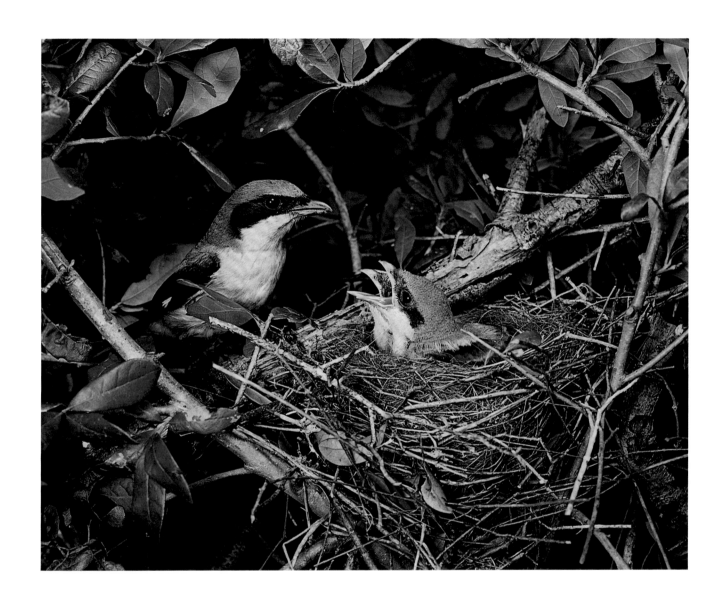

[6] LOGGERHEAD SHRIKE

Lanius ludovicianus

DECORATED IN rust-orange and black, the male
Black-headed Grosbeak is an unmistakable summer resident of western
woodlands. His mate is plainer, striped with brown and white, but she has
the same overgrown bill shape. Moving slowly and methodically through
dense foliage of oaks and other trees, this grosbeak is likely to be heard
before it is seen; it has a song of rich whistled phrases, sounding rather
hurried, like a nervous American Robin. At times, the male will even sing
while he is taking a turn sitting on the nest to incubate the eggs.
Most Black-headed Grosbeaks spend the winter in Mexico. In the mountains
west of Mexico City, they demonstrate a curious ability: these are among the
few birds capable of eating Monarch butterflies. Apparently they are immune
to the milkweed chemicals that make the Monarch
noxious to most other songbirds.

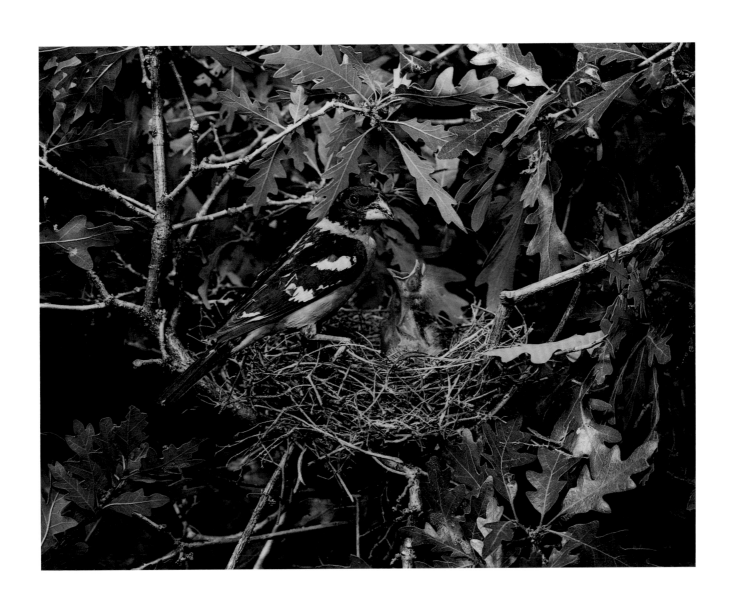

[7] BLACK-HEADED GROSBEAK

Pheucticus melanocephalus

AROUND THICKETS and brushy places of the southern states, on hot mornings in summer, the rich, low-pitched warbling of the Blue Grosbeak is a familiar sound. When the male is seen, it might be mistaken at first for an Indigo Bunting – the other dark-blue songbird of semi-open country. However, the grosbeak is larger, with a much thicker bill, and its wings are crossed by broad bands of orange-brown. Although Blue Grosbeaks are most numerous in the far South, near the Gulf Coast and the Mexican border, they may be found nesting as far north as New Jersey, the upper Midwest, and northern California. In recent years they have been gradually extending their range farther north. During the winter, most Blue Grosbeaks are south of the United States, in Mexico or Central America.

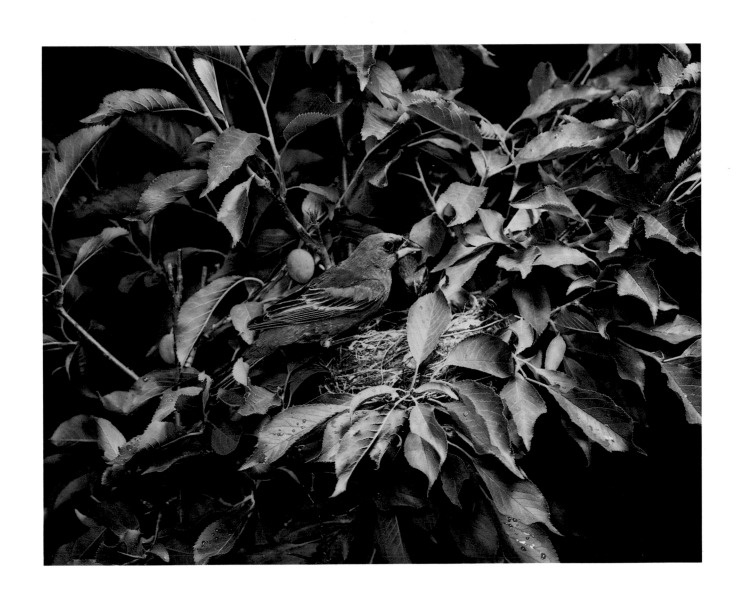

[8] BLUE GROSBEAK

Guiraca caerulea

STUNNING IN scarlet and sable, the male Scarlet Tanager

brings tropical color to woodlands of the Northeast every summer.

He shows this bright finery only then: in fall, before migrating to South

America for the winter, he molts into an olive-green plumage,

similar to the appearance that the female has all year. Scarlet Tanagers are

fairly common in deciduous woods, especially those dominated by oaks.

Typically they stay high in the trees, searching for caterpillars and other

insects among the foliage, and they may be overlooked easily. Their songs,

series of rich whistled phrases, may suggest the melodies of the American

Robin, but the tanager has a burry or buzzy undertone to its voice.

Cutting of trees, and the resulting loss of forest habitat, could create

problems for the Scarlet Tanager on both

its summer and winter ranges.

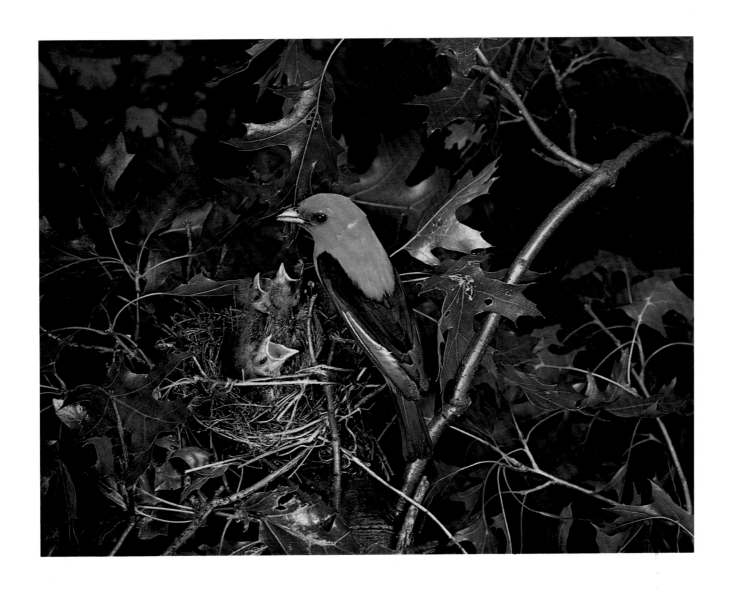

[9] SCARLET TANAGER

Piranga olivacea

TANAGERS are mostly tropical birds, and no other member of
the group can be found so far from the tropics as the Western Tanager.
In summer, it carries its exotic colors as far north as the edge of the
Northwest Territories in Canada. Males are the only North American birds
that are black and yellow with bright red faces; females are patterned
in yellow and gray, with the red on the head faint or lacking.
Western Tanagers usually build their open cup-shaped nests in tall pines
or firs, and typically quite high above the ground. Although they nest
mainly in the cool conifer groves of montane and northern climates,
migrants travel through the lowlands, commonly appearing in
dry valleys or even suburban gardens of the West during spring and fall.
Despite the loss of some habitat with the cutting of mountain forests,
Western Tanagers are still reasonably numerous.

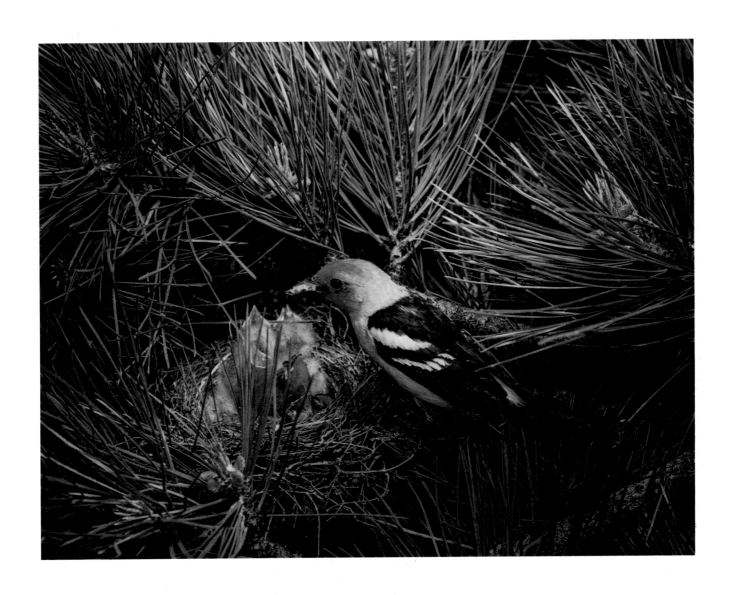

[10] WESTERN TANAGER

Piranga ludoviciana

Saucy and bold, noisy and colorful, the Blue Jay is
hard to overlook – except while it is tending its nest, when it becomes
quiet and secretive. A resourceful and adaptable bird, it dines on a wide
variety of things, including acorns and other nuts, berries, seeds, many kinds
of insects, and sometimes the eggs or young of other birds. With this
omnivorous diet it is able to survive year-round even in cold climates.
In some years, however, big flights of Blue Jays move south in fall,
with hundreds sometimes being seen at concentration points along
the Atlantic Coast and the Great Lakes. Although several kinds of jays that
are blue may be found in the West, the genuine Blue Jay is essentially
an eastern bird. In recent years it has been expanding its range
into parts of the Northwest.

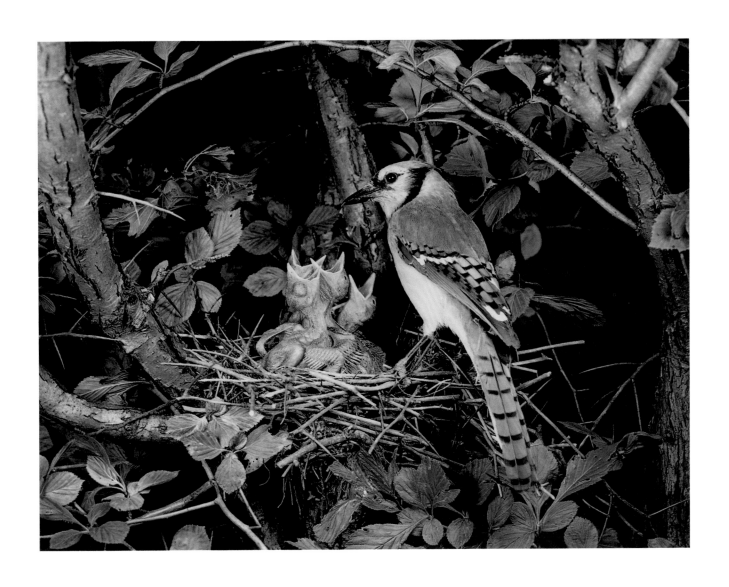

[11] BLUE JAY

Cyanocitta cristata

ALTHOUGH they are close relatives of the blackbirds, most orioles
are brightly colored, with strong patterns of yellow, orange, or chestnut.
The male Hooded Oriole is known by his orange-yellow hood encircling
a black face mask, and by the markings of white on his black wings.
This is a bird of the Southwest, often found along rivers through
dry country. In towns and in California canyons it often builds its nest
among palm fronds. In southern Texas, where Spanish moss festoons the
trees, the oriole may hide its nest among the stringy strands of this air plant,
as shown in this photograph. During recent years the Hooded Oriole has
become much less numerous in parts of its range, especially in Texas.
It seems to be a particular target for the Bronzed Cowbird,
a nest parasite that has been increasing in that area.

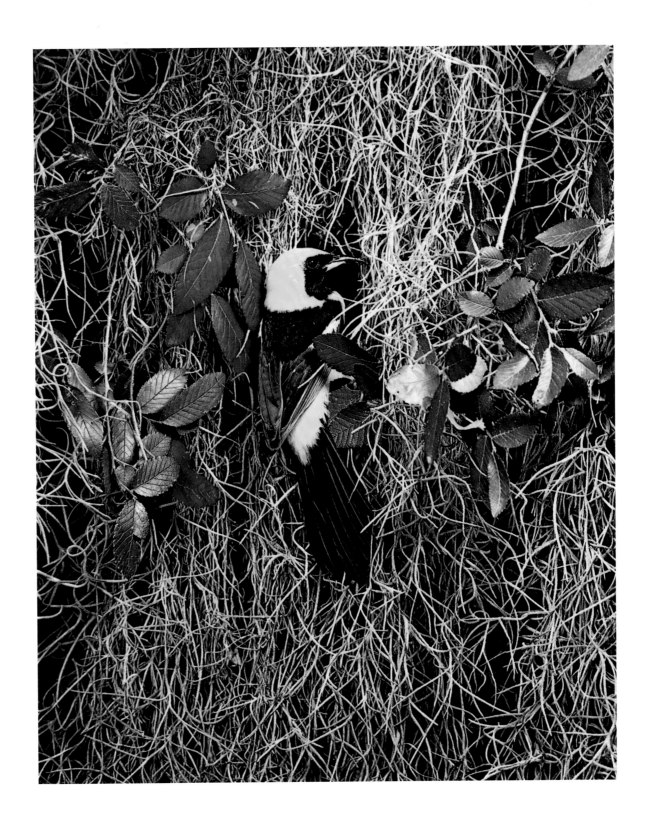

[12] HOODED ORIOLE

Icterus cucullatus

Over summer meadows in the northern and eastern states, a tinkling, sputtering, bubbling birdsong often seems to include the phrase *bob-o-link*. The author (and namesake) of this sprightly melody is a small songbird, the Bobolink, related to the blackbirds and meadowlarks. The male shows this relationship in summer, when he is mostly black, with patterns of yellow, white, and brown on his back, striking as he flutters over the fields to sing. Far less noticeable is his mate, striped with buff and brown, well camouflaged as she tends to her nest in the tall grass. Bobolinks are long-distance migrants, traveling in great flocks in spring and fall, reaching the pampas of Argentina in winter. On their summer range they will nest in hayfields, but many nests are lost if the hay is harvested before the young birds are able to fly. As natural meadows become scarcer, Bobolinks are disappearing as well.

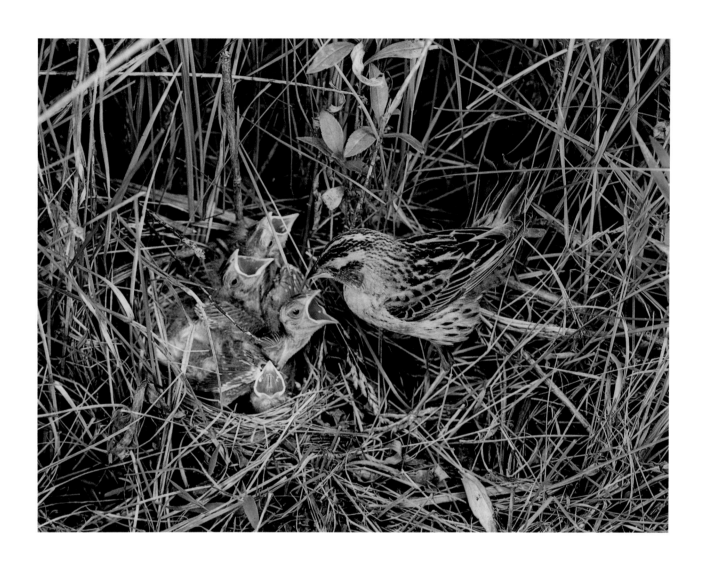

[13] BOBOLINK

Dolichonyx oryzivorus

If it is startled from the ground in an open field,
the Eastern Meadowlark whirs away low over the grass, looking
chunky and brown, flashing white feathers in its tail. Only when it lands
and turns around does it show the bold black "V" mark on its yellow chest.
From the Great Plains to the Atlantic Coast, this bird inhabits meadows,
weedy pastures, and the margins of farm fields, greeting spring mornings
with a clear whistled song. In addition to its eastern range (and despite
its name), the Eastern Meadowlark also occurs from our southwestern states
south through Central America to northern South America. In some parts
of this wide range, numbers of this species have been diminishing
recently – especially in our eastern states, where good
grassland habitat is gradually disappearing.

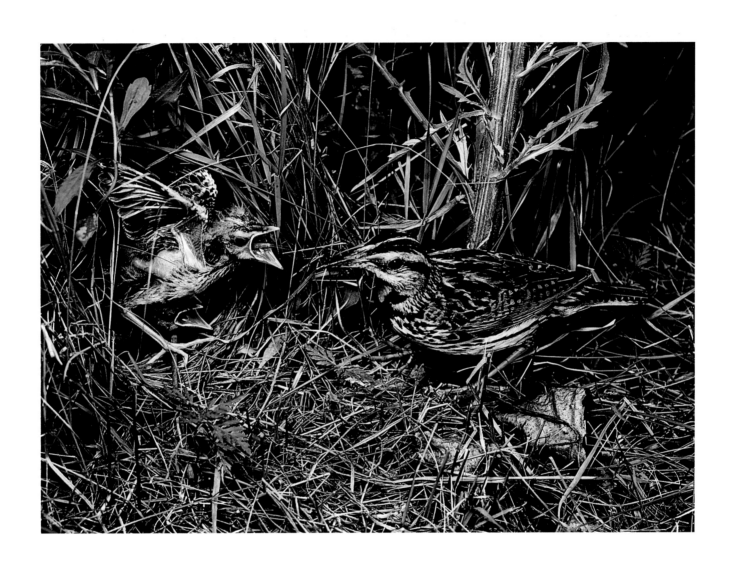

[14] EASTERN MEADOWLARK

Sturnella magna

WHEN John James Audubon traveled west up the Missouri River
for the first time in 1843, he was surprised to notice that the meadowlarks
there sang differently from the ones he knew in the east – bubbling and
fluting in a quick, rich warble. He decided that they must represent
a different species, and he gave them the scientific name *neglecta*, since they
had been overlooked by earlier explorers. Bird watchers today still recognize
the Western Meadowlark mainly by voice, since it looks almost identical
to the eastern bird. There are places in the upper Midwest where both
species may be heard singing from the same fields. Both kinds of
meadowlarks choose nest sites on the ground among tall grass, arching grass
stems over to form a canopy above the nest itself, making it even harder
to discover. Western Meadowlarks have decreased in numbers
in some parts of their range recently, for reasons
that are not well understood.

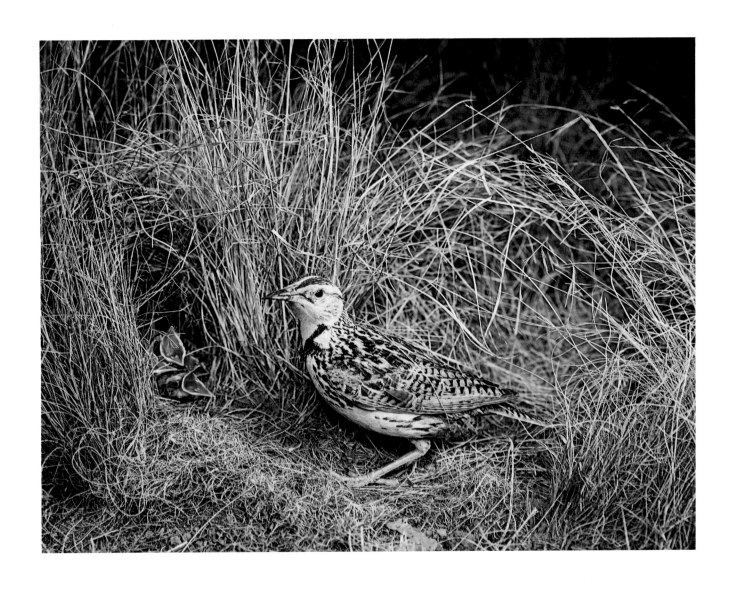

[15] WESTERN MEADOWLARK

Sturnella neglecta

FOXY RED above and boldly black-spotted below, the Wood Thrush is easily recognized both by sight and by its rich, flutelike song. At one time, this song was a very familiar sound in spring and summer throughout the forests of eastern North America, and even in well-wooded city parks and along tree-lined suburban streets. Unfortunately, the songs of this thrush are being heard less often with each passing year, as its population continues to drop. Conservationists, alarmed by its decline, suggest that the breakup of large forests into small woodlots makes Wood Thrush nests much more vulnerable to discovery by parasitic cowbirds. In many areas today, the thrushes succeed in raising mostly young cowbirds rather than their own offspring. Another factor in the decline may be the cutting of forests in southern Mexico and northern Central America, the heart of the wintering range for this species.

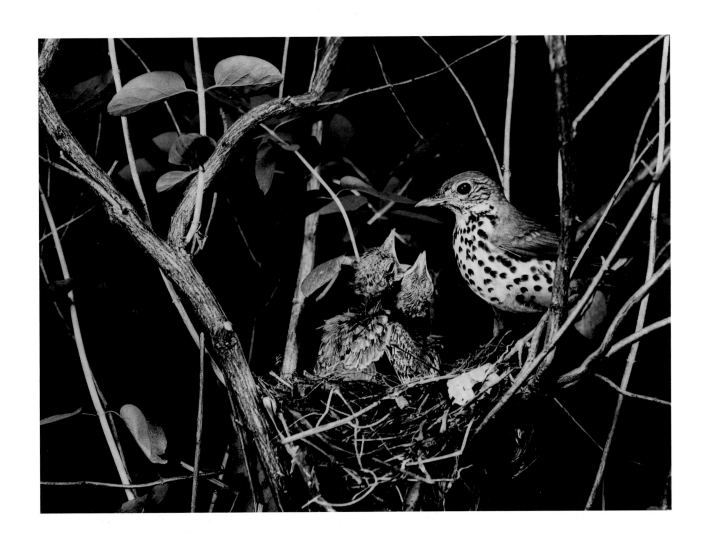

[16] WOOD THRUSH

Hylocichla mustelina

WITH THE approach of sunset in northern woods, a song rises from
the trees, sounding as pure as the evening air itself. A long clear whistle
leads into a bubbling series of notes that fades into silence; it is followed,
after a thoughtful pause, by a similar phrase on a different pitch. The singer
is the Hermit Thrush, a shy bird of the forest understory. When seen well,
it may be separated from other brown thrushes by the pattern of its
upperparts, its reddish-brown tail contrasting against the olive-brown of
its back. Hermit Thrushes have a wide range in summer across northern
and western conifer forests. The most richly colored birds, like the one seen
here, nest in the Northeast. This is the only brown thrush likely to be seen
in the United States in winter; the others migrate to the tropics,
where they may be losing their wintering habitat
as tropical forests are felled.

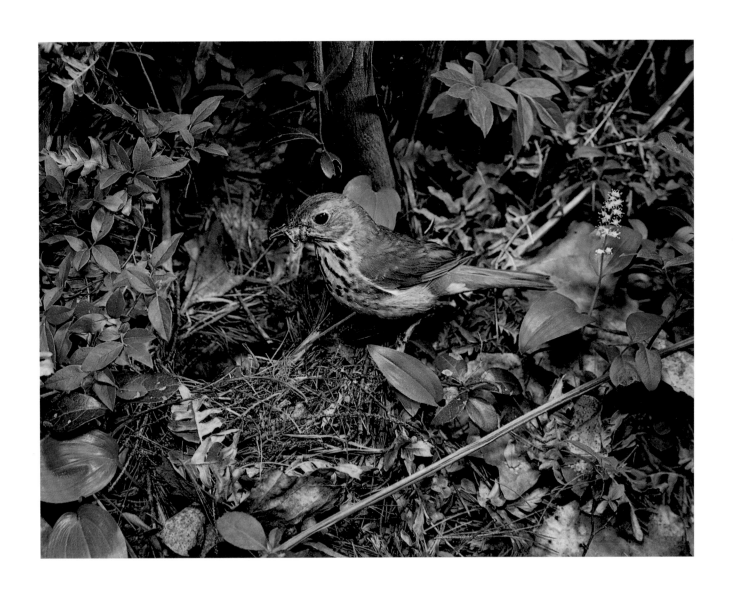

[17] HERMIT THRUSH

Catharus guttatus

IN THE SHADOWS of the forest floor, this small bird
builds a well-hidden nest that is rounded and domed over with an entrance
on the side, suggesting an old-fashioned oven. The Ovenbird itself is often
well hidden as well, as it walks about on the brown leaf-litter, stepping
daintily, holding its short tail cocked up above the level of its back.
However, its song is familiar: a ringing *teacher, TEACHer, TEACHER*,
giving it the common nickname of "teacherbird." Although it looks like
a pintsized thrush, it is really related to the warblers, most of which are
colorful treetop birds. Ovenbirds are widespread in summer in the eastern
United States and Canada, from the Atlantic Coast to the base of the
Rockies. Although they are still very numerous in some areas,
studies have shown that their nests are often parasitized by cowbirds,
giving cause for concern about their future numbers.

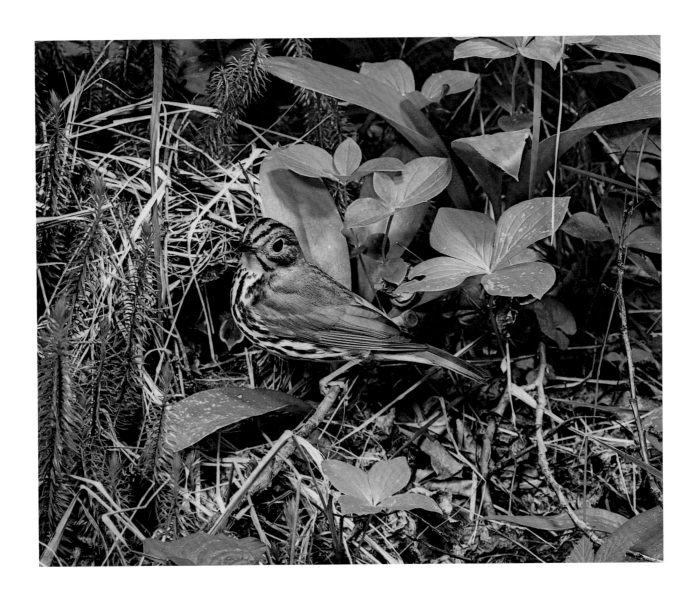

[18] OVENBIRD

Seiurus aurocapillus

TOWHEES announce their presence with the sound
of industrious scratching among dry leaves on the ground under dense
thickets. Observers who watch a towhee at work will see that the bird
scratches with both feet at once: making a little hop forward, the bird kicks
back with both feet simultaneously, sending the leaf-litter flying. After a few
vigorous kicks, the towhee stops to see what edible treasures it has turned up,
and then goes back to scratching. Spotted Towhees are very common
in western foothills and mountains, living in dry chaparral, on arid slopes
with scrubby oak thickets, and in the understory of open woods.
They usually place their nests on the ground, often at the base of a shrub.
The towhee in this photograph has tucked its nest against
a rusted tin can left behind at a miners' camp.

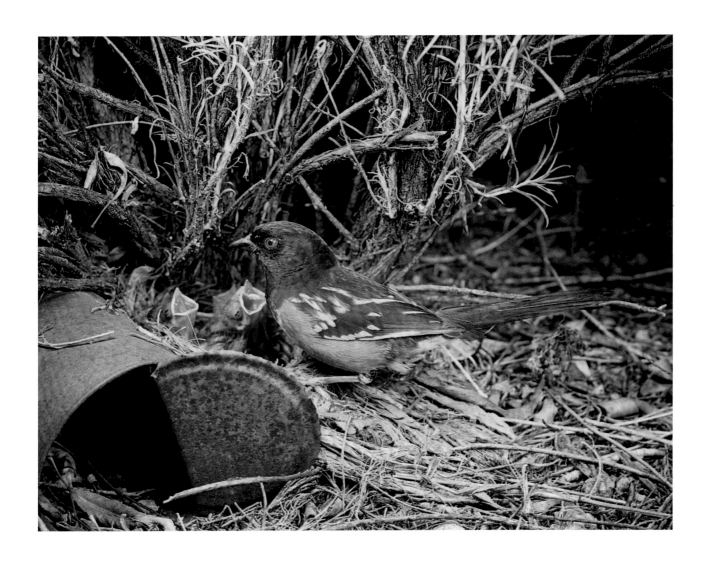

[19] SPOTTED TOWHEE

Pipilo maculatus

A SOFT MEWING like the cry of a kitten, coming from
a hillside covered with manzanita scrub or chaparral, may turn out to be
the voice of the Green-tailed Towhee. This elegant little finch, not much
bigger than a typical sparrow, is common in summer in many mountainous
regions of the West. Like other towhees, it often searches for food by
scratching on the ground with both feet, rummaging among the fallen leaves
for insects and seeds. Its nest is placed low, in a dense shrub or brushpile
or on the ground, in a sheltered spot where it is hard to find.
Most Green-tailed Towhees go to Mexico for the winter, but a few
spend the season in streamside thickets of the Southwest. During their
northward return in spring, they may pause for several days at a time
in parks or gardens of western valley towns.

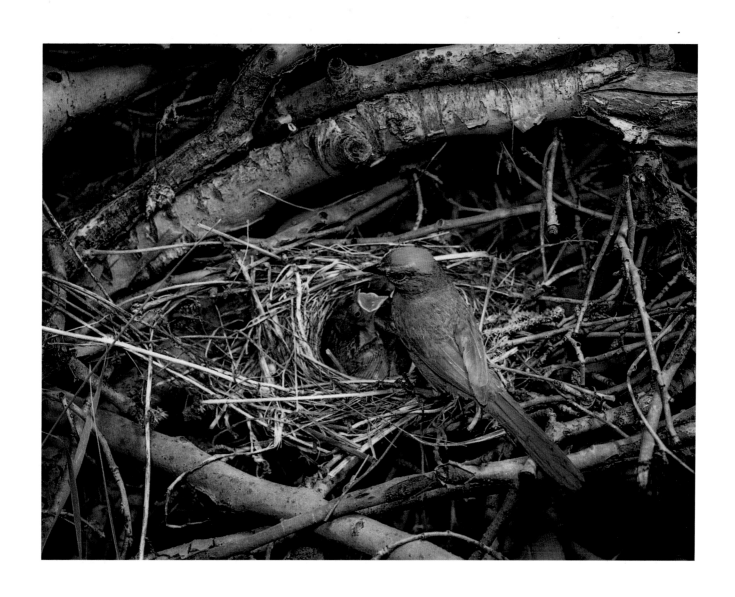

[20] GREEN-TAILED TOWHEE

Pipilo chlorurus

FEW THINGS can capture the feeling of late summer better than
the sight of a male American Goldfinch crossing an open meadow
in bounding, undulating flight, flashing in the sun like a gold coin, calling
a sprightly *potato-chip* at each peak in its up-and-down flight.
While most other songbirds begin nesting in spring or early summer,
goldfinches often put off their first nest of the season until mid-summer.
The likely reason? Seeds. Other seed-eating finches and sparrows will feed
their young mainly on insects, but the American Goldfinch starts
the youngsters early on mashed seeds. Apparently it delays its nesting activity
to take advantage of the weed and grass seeds that will be abundant by
late summer. In fall, the male molts into a duller plumage, similar to that
of his mate; large flocks wander through open country in winter,
often coming to backyard bird-feeders.

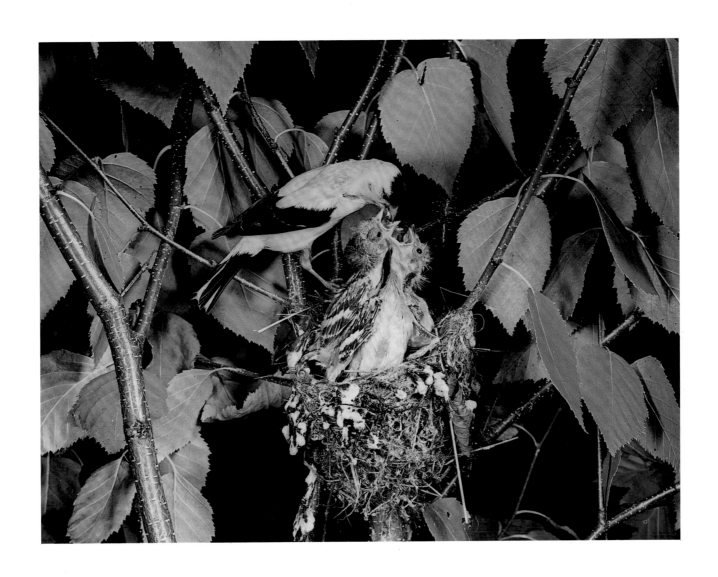

[21] AMERICAN GOLDFINCH

Carduelis tristis

PALE SKY-BLUE above, rust and white below
is the male Lazuli Bunting. Far less colorful is the female,
a plain warm-brown bird, unmarked except for two buffy wing-bars.
In the canyons and foothills of the West, this bunting is often numerous in
summer, living in chaparral and streamside groves. Males sing their bright
musical songs from high perches in the sunlight. Their nests, however, are
well hidden, placed close to the ground among dense shrubs. The male
shown here, apparently bringing food to the female at the nest, is displaying
unusual behavior; often the male stays away from the nest entirely,
leaving his better-camouflaged mate to provide all the care for the eggs
and young. Most Lazuli Buntings spend the winter in western Mexico,
where they forage in flocks around the edges of brushy fields.

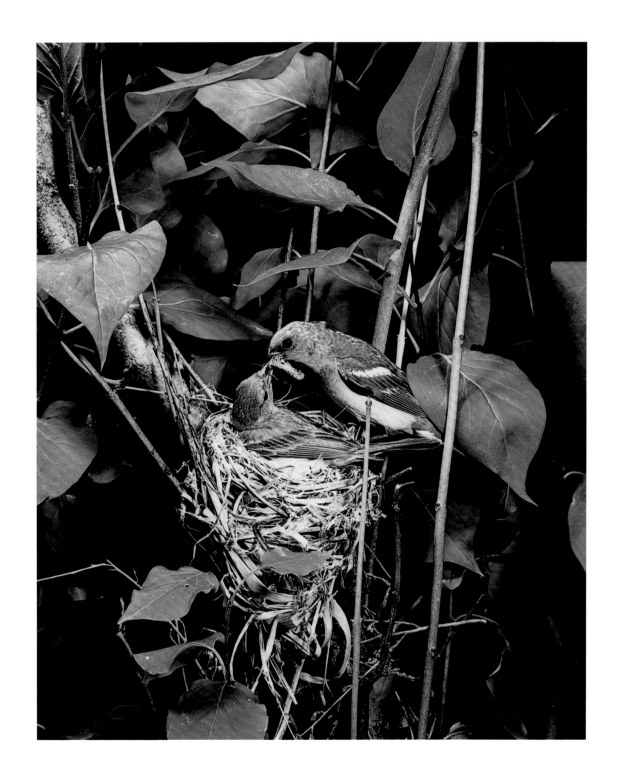

LAZULI BUNTING

Passerina amoena

MOST VIREOS are rather sedate songbirds, moving methodically
through the treetops, but this one is a busy little creature that loves dense
thickets. As it bustles about actively through the undergrowth, it sometimes
pauses at an opening to peer out suspiciously through one glaring white eye.
More frequently, it remains hidden. But it announces its presence often with
its rapid-fire song, an emphatic jumble with a restless or angry quality.
White-eyed Vireos are most common in summer in the Southeast,
with small numbers getting north to New England and the Great Lakes.
Many stay through the winter in Florida and along the Gulf Coast,
while others migrate to the northern edge of the tropics. During the last few
decades, populations of White-eyed Vireos apparently have been
in a gradual, long-term decline over much of their range,
for reasons that are not well understood.

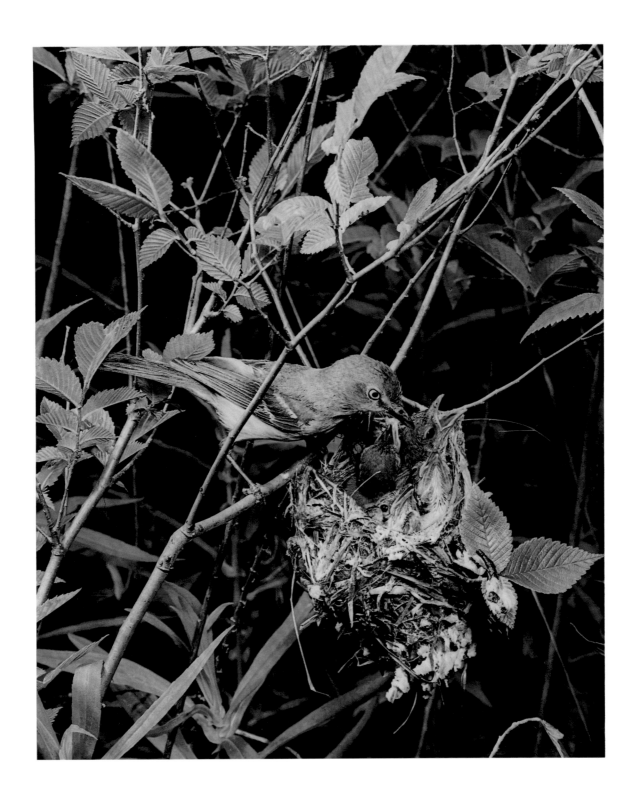

[23] WHITE-EYED VIREO

Vireo griseus

Vireos in general are solitary songbirds, seldom gathering in flocks, and this one just happened to be named for that family trait. Solitary Vireos are identified by their bold white "spectacles," white wing-bars, and white throats. Widespread in North America, they vary in color; the grayest birds, nesting in the Rocky Mountains and nearby ranges, are known as the "Plumbeous" race (meaning "lead-colored"). During the summer, these vireos are fairly common in forests of the lower slopes, singing their short burry phrases as they forage for insects among the oaks and pines. Their nests are easily recognized as being of the typical vireo type, a sturdy hanging basket, suspended by its edges from a forked twig. These nests are also sometimes easy to find, placed low in relatively open branches. The male Solitary Vireo will even sing at times while he is sitting on the nest, incubating the four lightly-spotted eggs.

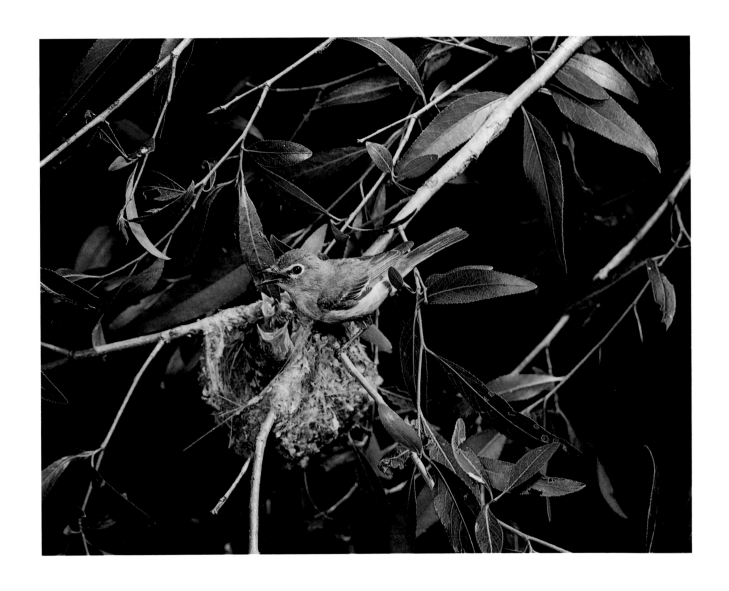

[24] PLUMBEOUS SOLITARY VIREO

Vireo solitarius plumbeus

MANY MEMBERS of the flycatcher family are subtly colored,
but the male Vermilion Flycatcher glows brilliant red with accents of black.
Widespread in the open country of South and Central America, this tropical
bird crosses the border into our southwestern states. It is partial to areas near
water, and may be discovered perching on low branches near ponds or creeks
in desert country. As bright as the male is, he calls further attention to
himself in the breeding season by performing a sort of sky dance:
puffing up his feathers until he appears almost round, he flutters about high
in the air in an erratic way, singing all the while. The female, more modest
in color and behavior, builds the nest in the fork of a mesquite or other
short tree. Numbers of Vermilion Flycatchers have been declining
recently in parts of their range, especially in Texas.

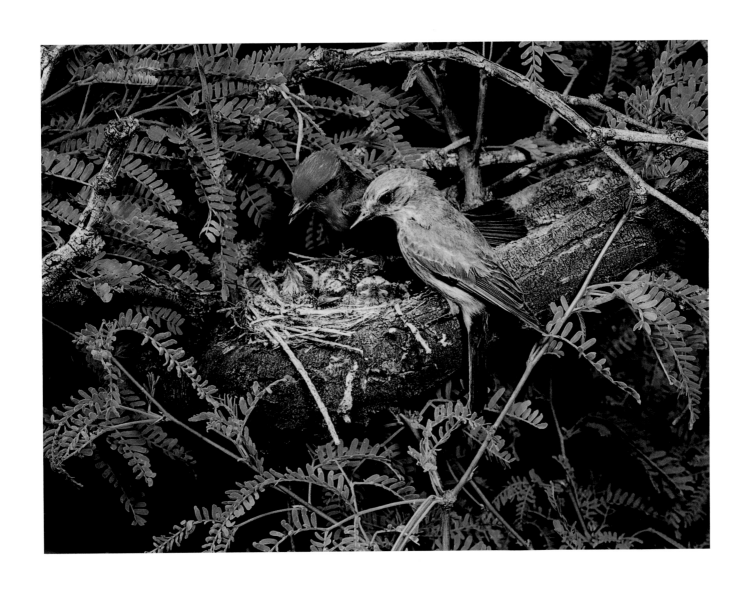

[25] VERMILION FLYCATCHER

Pyrocephalus rubinus

MEMBERS OF the flycatcher family are known for
their feeding behavior: they perch and wait, watching for flying insects,
and then sally out to catch these insects in mid-air, snapping them up in
their wide, flat bills. Several of the smallest flycatchers are classified in the
genus *Empidonax* (meaning "king of the gnats"). All have contrasting
eye-rings and wing-bars and are hard to tell apart by sight; but
their songs differ, and they choose different habitats in nesting season.
The Yellow-bellied Flycatcher is a retiring little bird that summers around
sphagnum bogs in the spruce woods of Canada and the northern rim of the
United States. Its nest, hidden among sphagnum moss or other dense cover
on the ground, is usually almost impossible to find. Yellow-bellied
Flycatchers spend the winter in Mexico and Central America,
where the cutting of their favored forest habitat may
pose problems for them in the future.

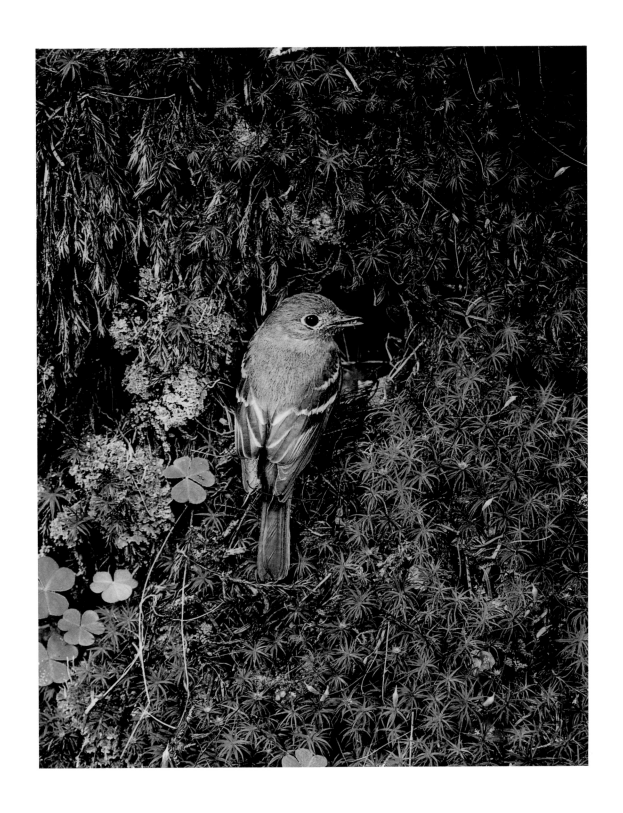

[26] YELLOW-BELLIED FLYCATCHER

Empidonax flaviventris

PINK-SIDED Juncos are sometimes called "snowbirds,"
an affectionate term for these softly-colored little birds that come south
with the first snowfalls of late autumn. Around the edges of winter woods,
in neglected weedy corners of parks and gardens, small flocks of juncos may
be found feeding on the ground. If disturbed, they fly up into the bushes,
flashing white outer tail feathers and making little clicking call notes.
During the summer, juncos may be found in cooler forested regions from
Alaska to the northeastern states and south throughout the mountains
of the West. Over this wide range, they vary strikingly in color.
Scientists disagree as to how various forms should be classified: some
would call them all races of a single species, Dark-eyed Junco,
while others would separate them. The Pink-sided form,
shown here, nests in the northern Rocky Mountains and
spends the winter in foothills of the Southwest.

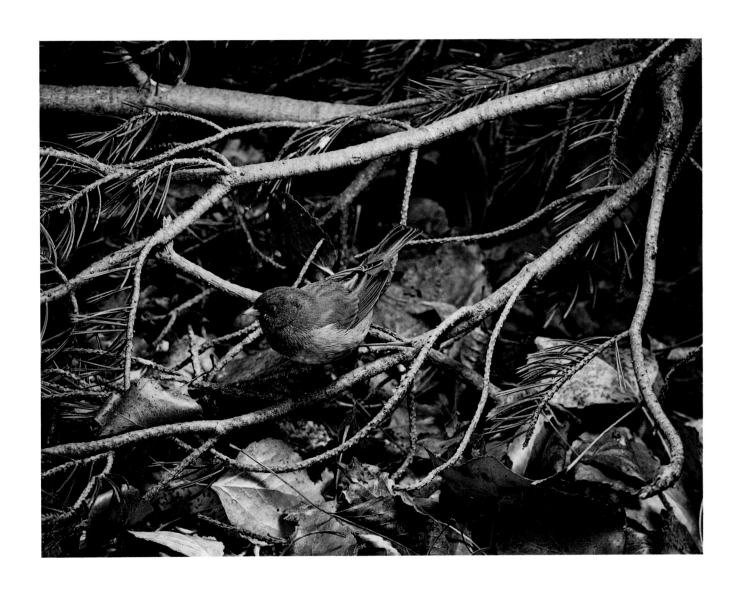

[27] PINK-SIDED JUNCO

Junco hyemalis mearnsi

FEW OTHER small birds wear such a startling expression
as this junco, with its glaring yellow or orange-yellow eyes. At one time
the bird was known as the Mexican Junco – another good name, as its range
extends over most of the mountains of Mexico. North of the border, it lives
only in a few of the higher ranges of New Mexico and Arizona. There it can
be found year-round in the cool forests of pine and fir, foraging on the
ground with a curious shuffling walk, or singing its varied musical trills
from high branches of trees. Unlike the other juncos farther north,
the Yellow-eyed Junco is quite sedentary, almost never straying away
from these mountain forests. As long as its upland habitat
is protected, this bird's future seems secure.

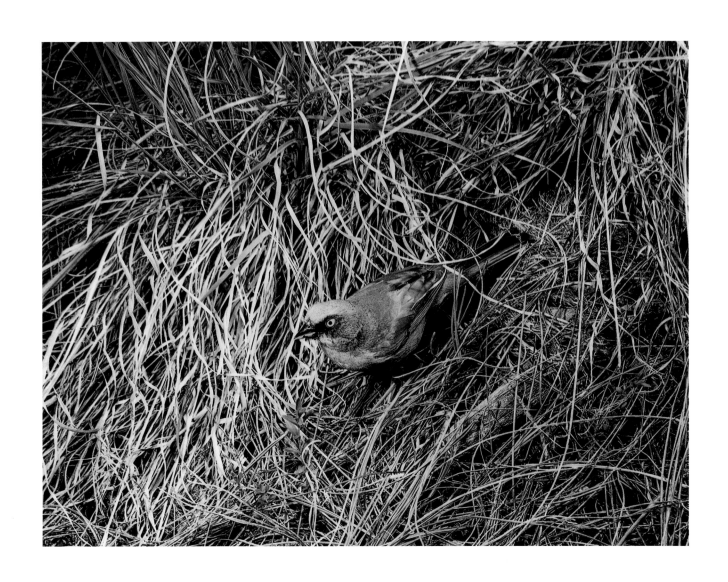

[28] YELLOW-EYED JUNCO

Junco phaeonotus

FAR BIGGER than other wrens found in North America,
decorated with spots and stripes and bars, the Cactus Wren is an
unmistakable denizen of the southwestern deserts. Although many of its
relatives are fine singers, this wren can manage only a variety of harsh
rasping notes. Its song is a repetitive series, *chug-chug-chug-chug*, suggesting
the sound of an old car that won't quite start. But what Cactus Wrens lack
in musical quality, they make up for in personality. Pairs or family groups
are often seen hopping about boldly on the chollas and prickly-pear cactus,
or dashing across the desert floor. They build football-shaped nests,
with the entrance at one end, wedged into a cactus or a thorny shrub.
Cactus Wrens are still very common over much of the Southwest,
but apparently their numbers are diminishing
in parts of Texas and California.

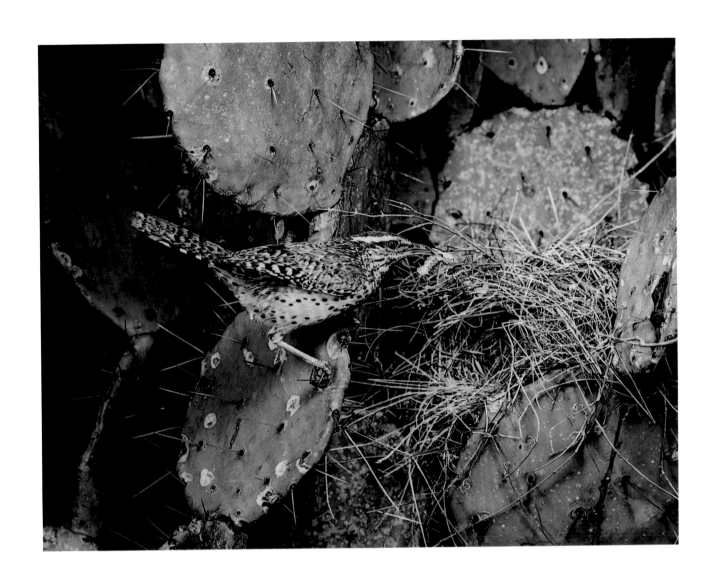

[29] CACTUS WREN

Campylorhynchus brunneicapillus

IN EARLY SPRING in the north woods, a tinkling, rippling,
trilling song comes from the shadows, thin but musical, running on
and on. Finding the singer can be a serious challenge: this is the voice of the
Winter Wren, a shy little recluse that often remains unseen. Seemingly acting
more like a mouse than a bird, this wren hops and scurries about under
fallen logs and through the densest thickets, but it will occasionally pop up
to look curiously at a person who waits patiently nearby. Winter Wrens build
their nests in holes in stumps or dead trees, among the upturned roots of
downed trees, or in crevices among rocks. For some obscure reason,
the male may also build some additional or "dummy" nests that
are never used. Despite their name, these wrens do not stay
through the winter in most northern areas, except in
milder climates along the Pacific Coast.

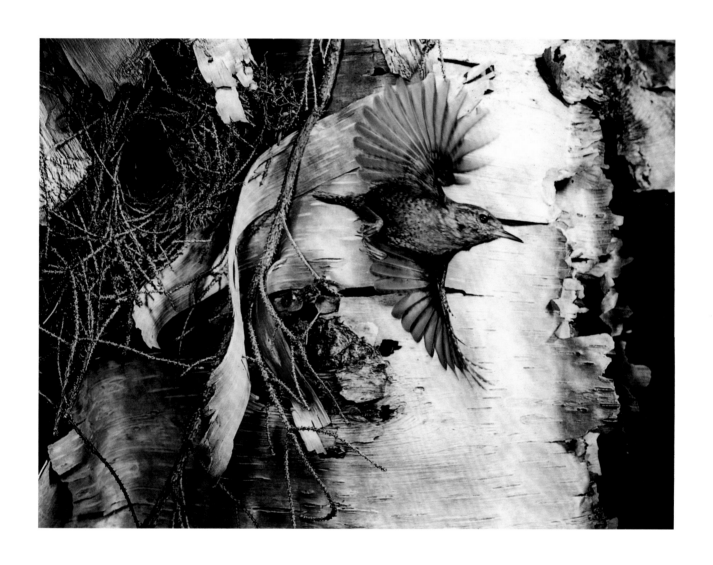

[30] WINTER WREN

Troglodytes troglodytes

SMALL BIRDS that flit actively through the trees,
wonderfully diverse in their colors and patterns, the warblers are favorites
with many bird watchers. North America has more than fifty kinds of these
"butterflies of the bird world"; in some places, during the peak of spring
migration, more than twenty-five of these might be seen in a single day.
Decorated in yellow, black, and blue-gray, the Magnolia Warbler
is a summer resident of eastern Canada and the northeastern United States.
It hides its nest among the low branches of a dense young spruce or
hemlock. For the winter, most Magnolia Warblers fly to the Yucatàn
Peninsula or nearby areas of Mexico and Central America.
On their migration through the southern states, they might
pause briefly in the magnolia trees for which
they were, mistakenly, originally named.

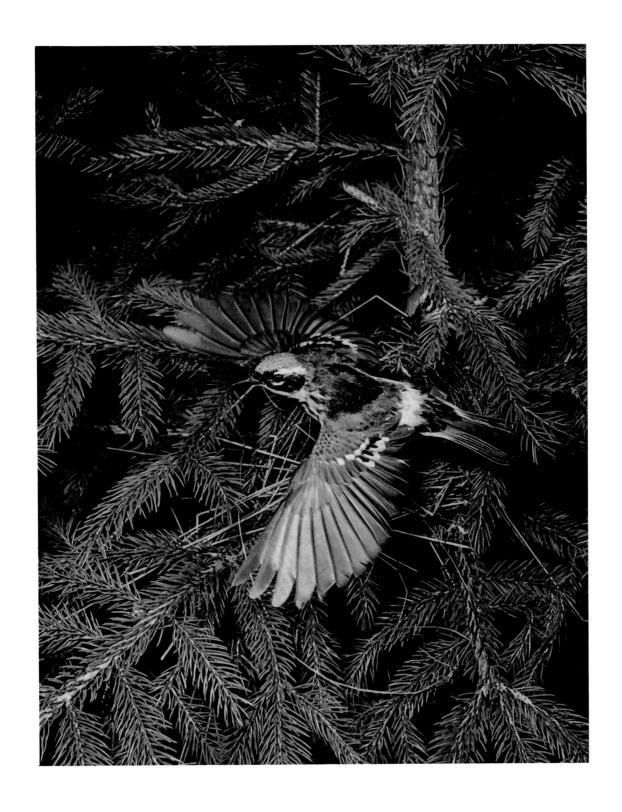

[31] MAGNOLIA WARBLER

Dendroica magnolia

One of the smallest members of the warbler clan,
the Northern Parula often sings from high in the trees, remaining unseen
as it repeats its distinctive song: a buzzy sputter that climbs the scale and
then snaps off abruptly at the top. When it hops to an open twig, the bird is
easily recognized by its blue-gray back, yellow chest, and white spots around
the eyes. Northern Parulas are widespread in the East in summer, from the
Gulf Coast to southern Canada, but only where they can find suitable sites
for nesting. They like to build their nests inside hanging masses of stringy
plant material in the trees – Usnea lichen in the North, Spanish moss in
the South. In such concealment, the nest is almost impossible to detect
without watching the comings and goings of the parent parulas.

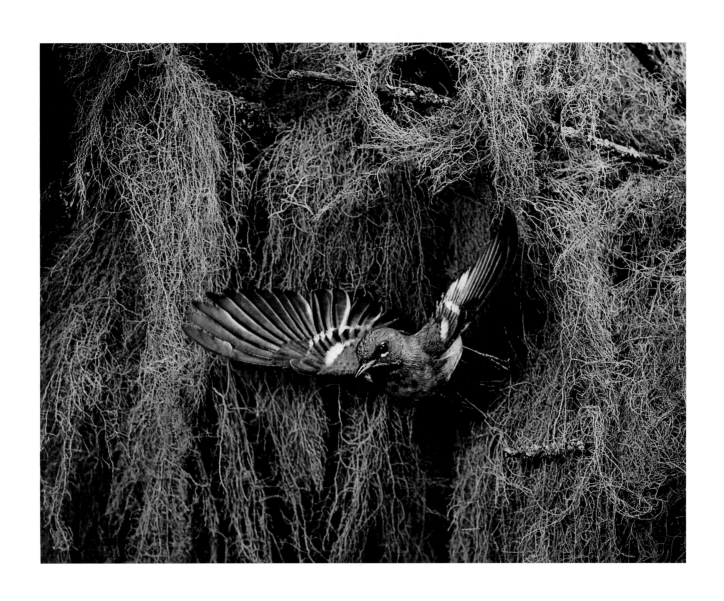

[32] NORTHERN PARULA

Parula americana

When the Pilgrims landed, this warbler was probably
less numerous than it is today. A bird of second-growth thickets and
woodland edges, it may have been scarce when eastern North America was
cloaked in primeval forest. The painter Audubon, traveling throughout
that region in the early 1800s, encountered this bird only once. Today the
Chestnut-sided Warbler is fairly common in summer in parts of eastern
North America, including some of Audubon's old haunts; it spends
the winter along forest edges in Central America. It is known by its
yellow cap, black and white face, and stripe of chestnut-brown down
the side of its body. When foraging for tiny insects among leafy thickets,
it hops and flits about actively, often holding its tail cocked up at a perky
angle. Studies in recent decades suggest that although it is still
numerous, the Chestnut-sided Warbler has been gradually
declining in numbers.

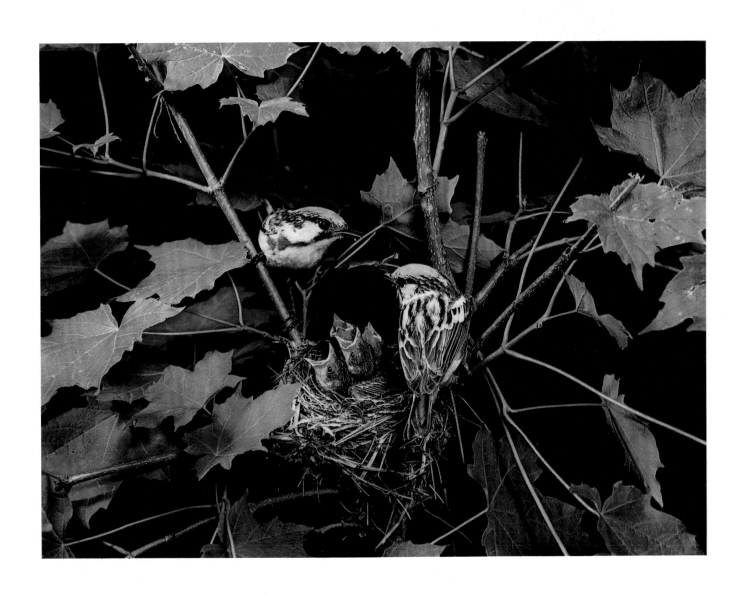

[33] CHESTNUT-SIDED WARBLER

Dendroica pensylvanica

THIS BIRD'S NAME could be misleading – twice.

Like many other warblers, it could not fairly be said to warble; in fact,

its staccato song sounds more like a sewing-machine shifting gears to a

faster speed. And it has no particular connection to the State of Tennessee.

Pioneer birdman Alexander Wilson happened to encounter his first ones

there, in the early 1800s, but those birds were merely passing

through in migration. Wilson was closer to the mark with

his scientific name of *peregrina*, or wanderer.

Plainer than most warblers, the Tennessee is white or pale yellow

below, olive and gray above. It spends the summer around bogs in the cool

forests of Canada and the northern edge of the United States, where it places

its nest on the ground. In winter in the tropics, little flocks of Tennessee

Warblers often feed on nectar in flowering trees,

even in towns and gardens.

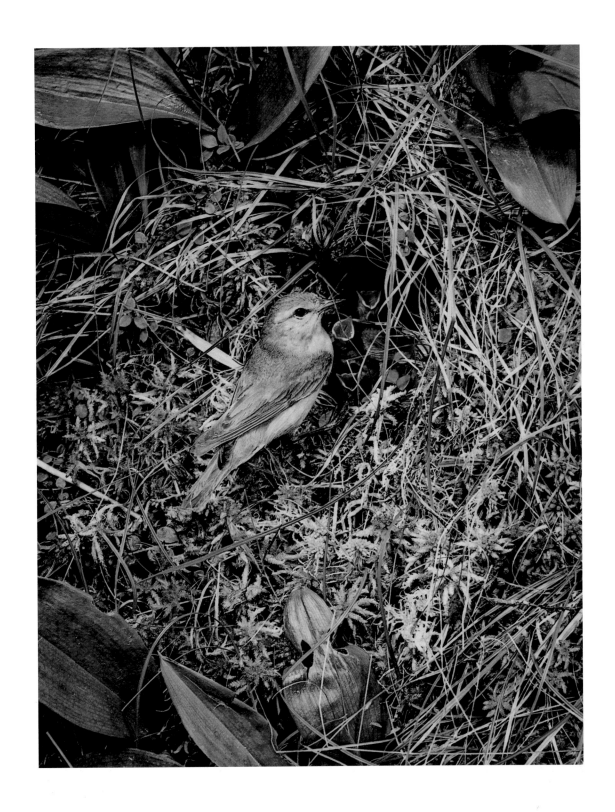

[34] TENNESSEE WARBLER

Vermivora peregrina

OF THE MORE than fifty kinds of warblers in North America, only one has adapted to life in open marshes. But that one has been highly successful: the Common Yellowthroat is indeed common wherever there are marshes, singing its quick *wichity-wichity-wich* from the tops of the cattails and tules. The male wears a bandit's black mask, set off by a pale stripe above and by the trademark yellow throat below. The female, lacking the mask, is often best recognized by habitat. Common Yellowthroats build open cup-shaped nests of grass and leaves, lashed to standing reeds in the marsh, or (as shown here) tucked into a briar tangle near the water. Although they are still widespread and fairly numerous, Common Yellowthroats have declined in population – along with most other marsh birds – as wetlands have been drained for agriculture or development.

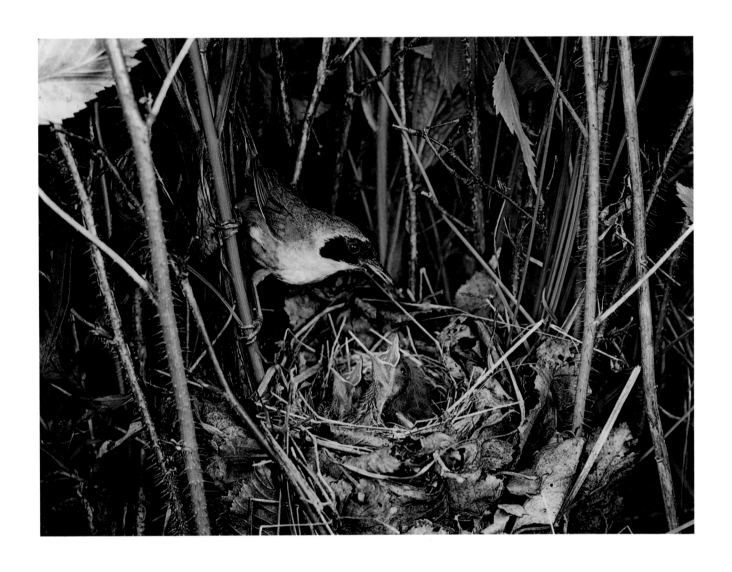

[35] COMMON YELLOWTHROAT

Geothlypis trichas

ONLY A CLOSE VIEW will reveal the slight patch of orange
feathers on the crown for which this bird is named. This is among the
plainest of warblers, the dull bird in a bright-colored clan. All its marks are
subtle: a darker eye-line, a faint pale eyebrow, blurry darker stripes on its
chest. Orange-crowned Warblers are found from coast to coast but are
far more numerous in the West, where they spend the summer in thickets
both high in the mountains and along the Pacific Coast. They build
their nests on the ground, under the shelter of a grass clump or the base of
a shrub. Compared to most warblers, Orange-crowns migrate only short
distances, and many stay through the winter in our southern states.
Because they can thrive in bushy or second-growth habitats,
they have not been affected as much as some warblers
by the cutting of forests.

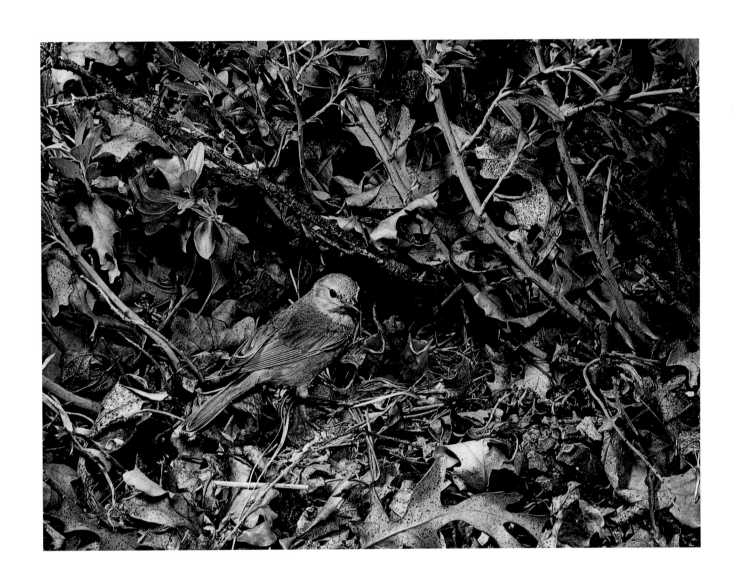

[36] ORANGE-CROWNED WARBLER

Vermivora celata

THROUGHOUT THE deciduous forests of the East,
Hooded Warblers haunt the leafy shadows of the undergrowth in summer.
They may be difficult to observe, but once seen, they are easy to recognize –
especially the males, with their striking black hoods. Females are often plainer,
but both sexes frequently flash white tail feathers in a quick fanning motion
as they hop about in the thickets. Although they are most numerous in
the southeastern states, their emphatic whistled songs may be heard in
summer as far north as the Great Lakes. They place their nests close
to the ground, in leafy shrubs of the woodland understory.
Because Hooded Warblers are denizens of the shady interior of
the forest, they have declined in numbers as more forests have been cut,
both within their nesting range and on their wintering grounds
in Mexico and Central America.

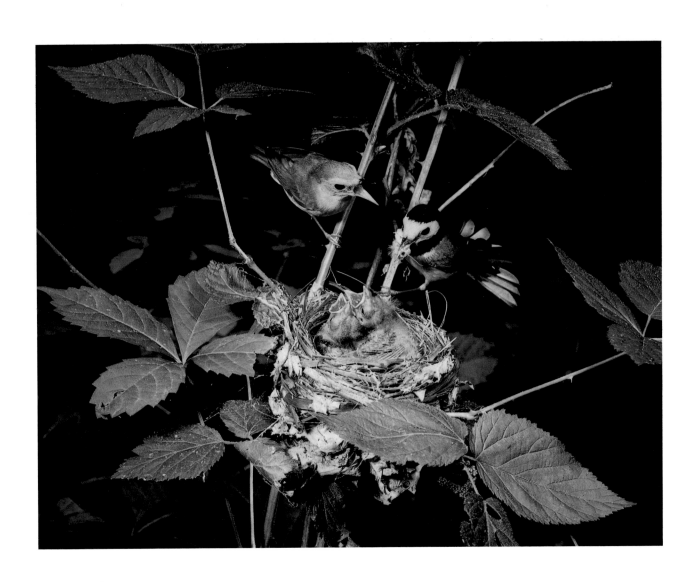

[37] HOODED WARBLER

Wilsonia citrina

ABOVE THE dark waters of eastern swamps,

the Prothonotary Warbler gleams like a drop of living gold.

Its unusual name comes from a group of official scribes in the Roman

Catholic Church, men who wore bright golden-yellow cloth, suggesting

this bird's rich color. Although its summer range reaches the southern edge

of the Great Lakes region, this is mainly a bird of the South, where males

chant their repetitive *weet weet weet* from high in the trees along every

bayou and backwater. Like most warblers, the Prothonotary is a migrant,

traveling to the tropics in fall. Unlike most others, however, it places

its nest inside a cavity in a tree, such as an old woodpecker hole or

a natural hollow in a dead stub. With the draining of swamps and

cutting of trees along southern rivers, the Prothonotary Warbler

has become far less numerous than it was in the past.

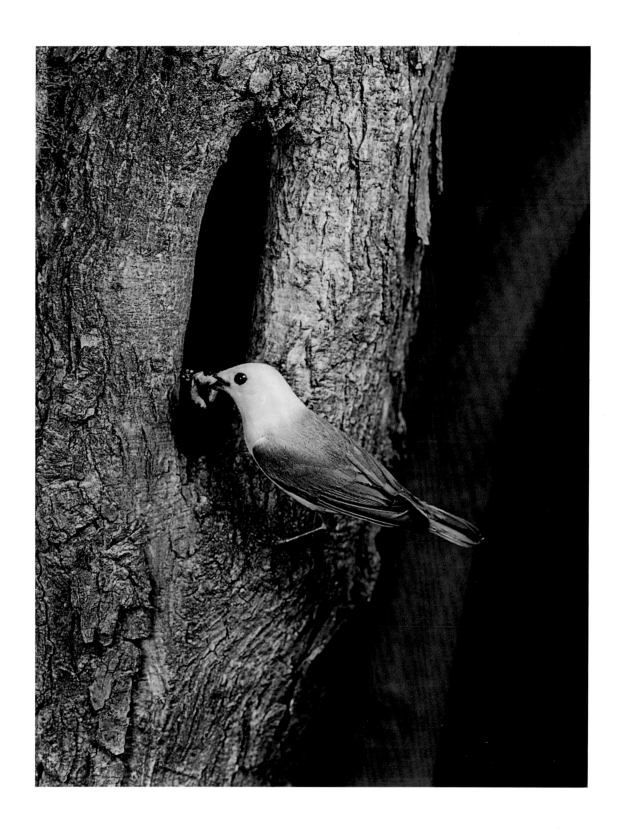

[38] PROTHONOTARY WARBLER

Protonotaria citrea

THE MAIN realm of the Grace's Warbler is the mountain forest
of Mexico and Central America, but it also extends north into the
southwestern United States during the summer. There it lives among
the pines, seldom straying to other habitats in the foothills or valleys.
Grace's Warbler seems like a modest bird, softly patterned in gray and
yellow, with a simple rising chatter for a song. It was named for the sister
of Elliott Coues, a young scientist who discovered it in Arizona in 1864.
Choosing a site high in a tree, the female Grace's Warbler often will build
her nest among a cluster of pine needles, where it may be very hard
to see from the ground. The population of this bird seems to be
holding up well in our area; however, it may be declining
to the south, as more forests are logged in
the mountains of Latin America.

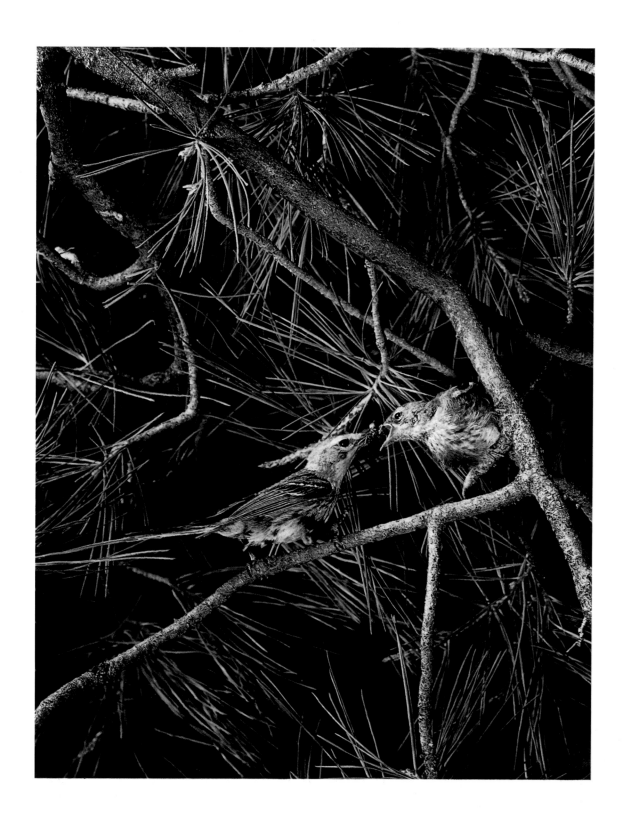

[39] GRACE'S WARBLER

Dendroica graciae

THE KIRTLAND'S WARBLER is one of North America's rarest birds.
Its summer range is almost entirely restricted to a few counties in Michigan,
and it winters only on a few islands in the Bahamas. It nests only in stands
of young jack pines, of the sort that spring up after a forest fire;
when the trees grow too tall, the warblers move out. Moreover, this bird
is a particular target of the parasitic Brown-headed Cowbird.
With the clearing of forest throughout the Great Lakes region,
large numbers of cowbirds have invaded Michigan, often laying their eggs
in the warblers' nests. Never a common bird, Kirtland's Warbler
declined to a dangerously low population of under 350 birds by the 1970s.
Conservationists have managed to boost its numbers since then,
trapping cowbirds in the nesting zones and using controlled burns
to create more habitat, but Kirtland's Warbler remains
a highly endangered species.

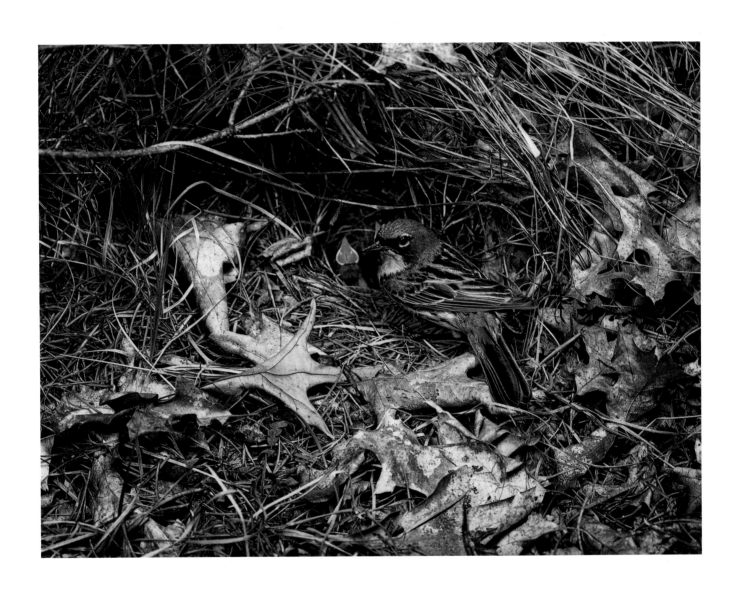

[40] KIRTLAND'S WARBLER

Dendroica kirtlandii

GLOWING BRILLIANT orange and black like a hot coal,
the male Blackburnian Warbler sings his thin, wiry song from the top of
a tall spruce in the North Woods. This little bird with its Halloween colors
is a typical summer resident of Canadian forests, with a few extending
south in the Appalachians as far as northern Georgia. It usually places
its compact, cup-shaped nest high in a spruce, pine, or other conifer.
An impressive traveler for its small size, the Blackburnian Warbler
migrates every fall to South America. There it spends the winter on
the slopes of the Andes, joining flocks with a multitude of multicolored
tropical songbirds. Widespread cutting of the Andean forests may spell
trouble for the birds that rely on them, both tropical residents
and migrants from North America.

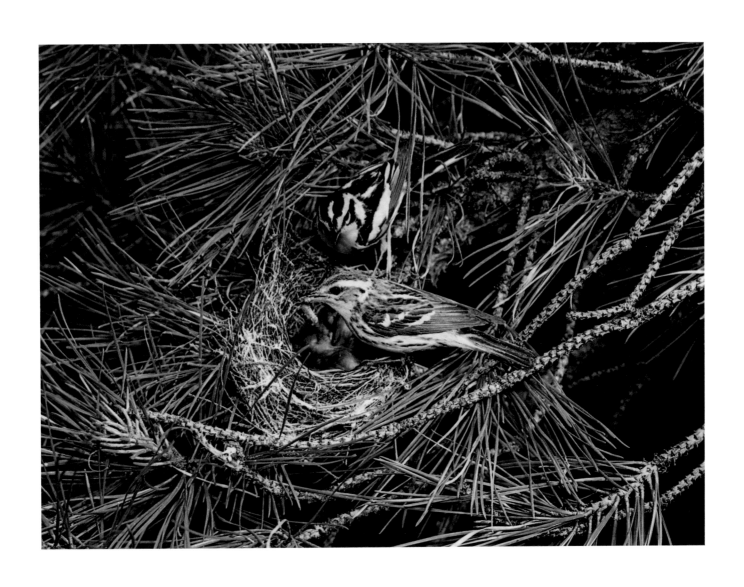

[41] BLACKBURNIAN WARBLER

Dendroica fusca

NONE OF THE northern warblers wears shades of bright red
in the plumage; such hues are sported only by tropical members of the
group. One such tropical species, the lovely Red-faced Warbler, crosses the
border into Arizona and New Mexico in summer. It is a bird of mountain
forests, often seen near streams through forests of pine or douglas-fir.
In many of its more northern relatives, males are much more colorful
than females; but the female Red-faced Warbler looks almost identical to
her mate, bright red on the face and throat, with a black mark like a scarf
draped over the top of the head. Although their colors would seem
to make them conspicuous and thus vulnerable, these warblers
build their nests on the ground, at the base of a shrub
or in a hollow on a steep bank.

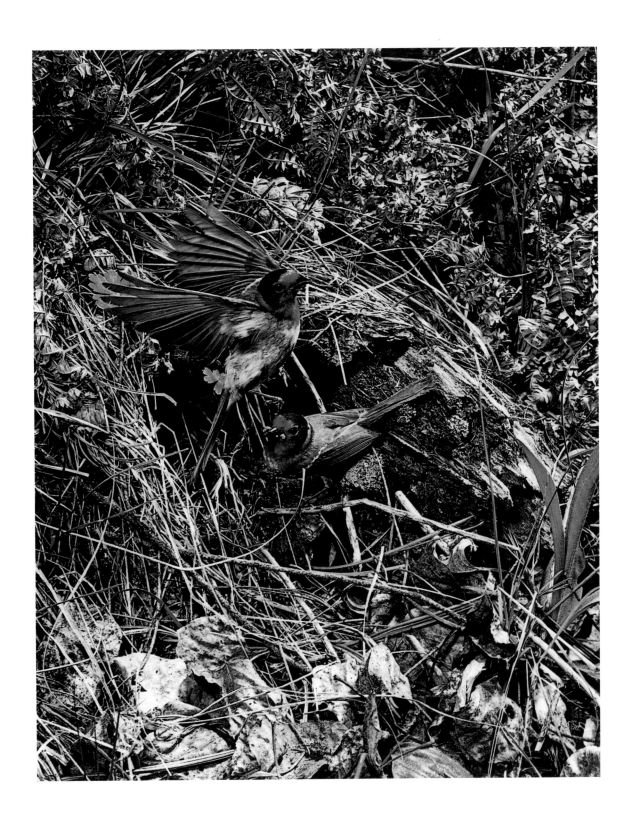

[42] RED-FACED WARBLER

Cardellina rubrifrons

WITH ITS SIMPLE but striking accents of black and gold,
the Golden-wing is among the most elegant of warblers. It is also among
those showing the most serious decline in numbers. During recent decades,
it has disappeared from several former nesting areas; today it is common
only in a few limited regions of the northeastern United States and extreme
southern Canada. Reasons for the decline of the Golden-winged Warbler are
complex. This bird is a close relative of the Blue-winged Warbler; the two
species seem to compete in some habitats, and they often interbreed. The
Blue-wing may be better able to adapt to manmade changes in habitat,
allowing it to spread into new areas and even to prosper there
while the Golden-wing gradually fades from the scene.

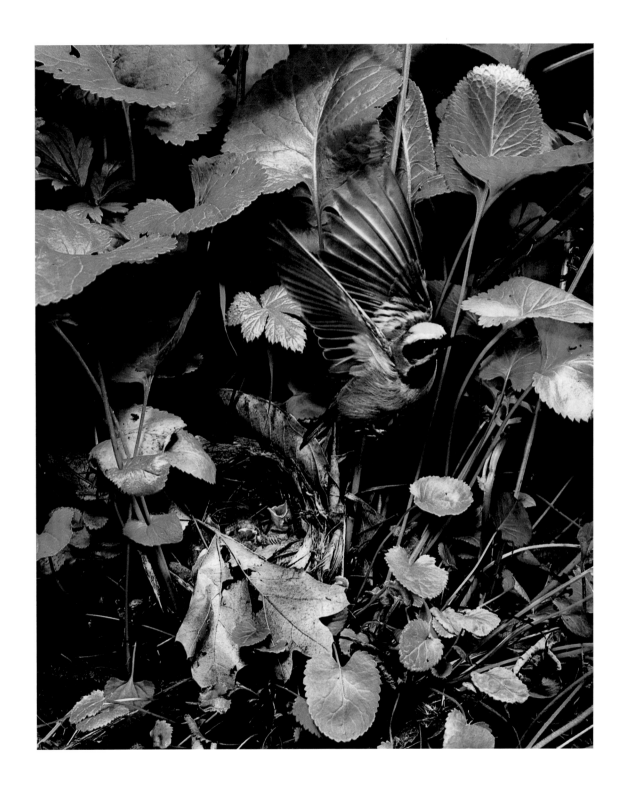

[43] GOLDEN-WINGED WARBLER

Vermivora chrysoptera

AT ONE TIME this bird was known as the Pileolated Warbler,
an antique word referring to its neat black cap. Even when this cap
is hard to see (and some females and young birds lack it altogether),
Wilson's Warbler may be identified by its overall color and its behavior.
It is yellow and green all over, without any of the markings of white shown
by so many warblers. A very small and active species, it often flips its tail up
and down expressively as it flits through the foliage. Wilson's Warblers
occur in summer all across Canada and Alaska, and well to the south in the
western mountains, especially in groves of willows and alders near water.
As migrants, they are far more common in the West than in the East.
Most Wilson's Warblers spend the winter in Mexico, where they
can survive in practically any wooded or brushy habitat.

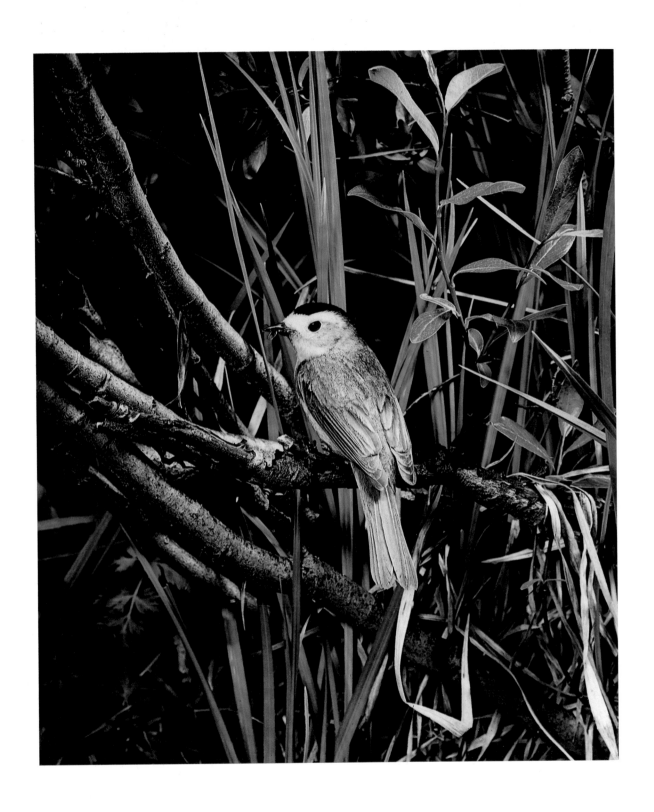

[44] WILSON'S WARBLER

Wilsonia pusilla

TO BE SURE of seeing the Bay-breasted Warbler in summer,
one must travel to the spruce forests of eastern Canada or the extreme
northern edge of the United States. There the male, strikingly accented in
chestnut and black, sings his squeaky phrases from the treetops;
his more softly colored mate goes about the work of building the nest,
hidden in a secluded spot on a conifer branch. Like other warblers,
Bay-breasts feed on insects, and they seem to have a particular liking
for the caterpillar known as the spruce budworm. When the budworms go
through high population cycles, the warblers increase in numbers also,
laying more eggs and raising more young to take advantage of this
insect bonanza. For a few years after a budworm outbreak in
the northern forest, bird watchers in eastern North America
may see more Bay-breasted Warblers during
spring and fall migrations.

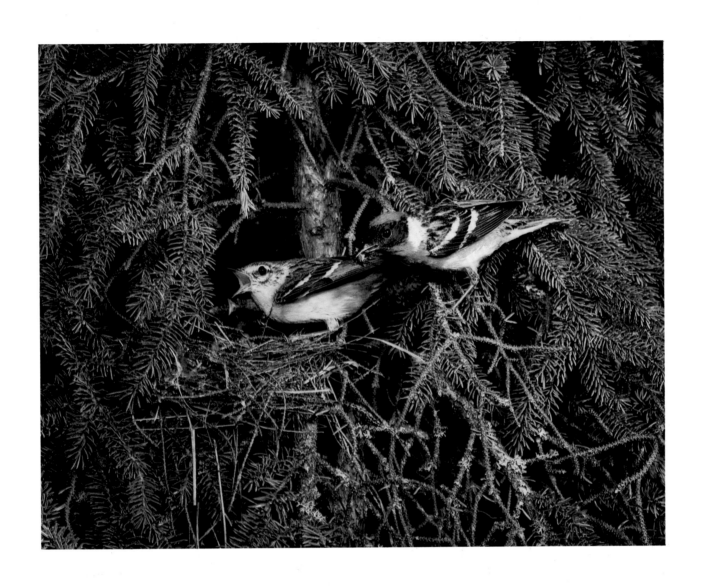

[45] BAY-BREASTED WARBLER

Dendroica castanea

A JUMBLE OF quick emphatic notes from the undergrowth announces this skulker. When the singer is glimpsed, it is known by its eye-ring, its blue-gray back, and the necklace of stripes on its yellow chest. The Canada Warbler migrates relatively late in spring and early in fall, spending more than half the year on wintering grounds in northern South America. Despite its name, its summer range includes not only eastern Canada but also the northeastern United States, and it extends south along the spine of the Appalachians as far as northern Georgia. Everywhere it haunts the understory of leafy woods, foraging low and placing its nest near ground level. Reliance on the interior of the forest makes it vulnerable to loss of habitat in both summer and winter.

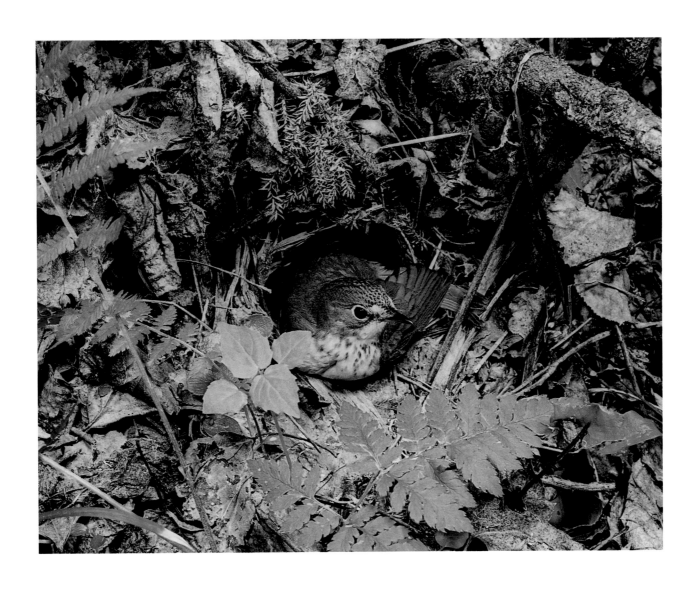

[46] CANADA WARBLER

Wilsonia canadensis

In the early days of bird study in North America, the concept of migration was not well understood. Pioneer ornithologists, roaming the continent in search of new species, sometimes would name a new discovery in honor of the place where they had found it – not realizing that their bird might have been merely passing through on its way to somewhere else. One such misnamed discovery was this warbler, which neither nests nor winters anywhere near the city of Nashville. Its summer range includes eastern Canada and the northeastern United States, as well as a disjunct area in the mountains of the West. With a simple but attractive pattern, the Nashville Warbler is known by its gray head, greenish back, white eye-ring, and contrasting yellow throat. In winter, little flocks of Nashville Warblers forage around the edges of woodlands in the mountains and valleys of Mexico.

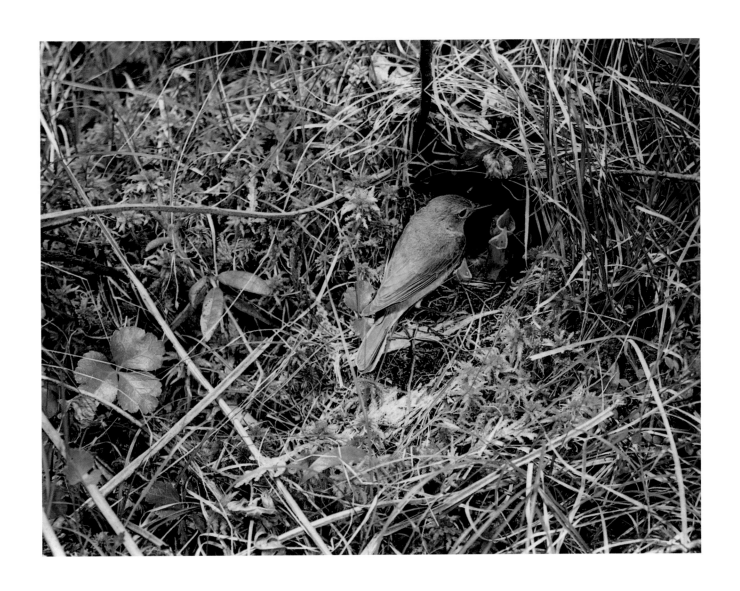

[47] NASHVILLE WARBLER

Vermivora ruficapilla

Rugged western foothills and canyons, rocky places
with thickets of scrubby oaks, provide a summer home for the Virginia's
Warbler. This is a rather plain and pale little bird, mostly gray and white,
with slight touches of orange on the head and yellow on the chest; it
may be known by its white eye-ring and the patches of yellow near the base
of its tail. Its song, a simple but musical trill, carries well across
the dry slopes. Virginia's Warblers hide their nests well, placing them
on the ground under clumps of grass, usually under thickets on
steep hillsides. Perhaps because their nests are so hard to find,
their breeding habits have not been studied in detail.
During the winter, Virginia's Warblers forage in
the scattered trees and brush of arid hills
in southwestern Mexico.

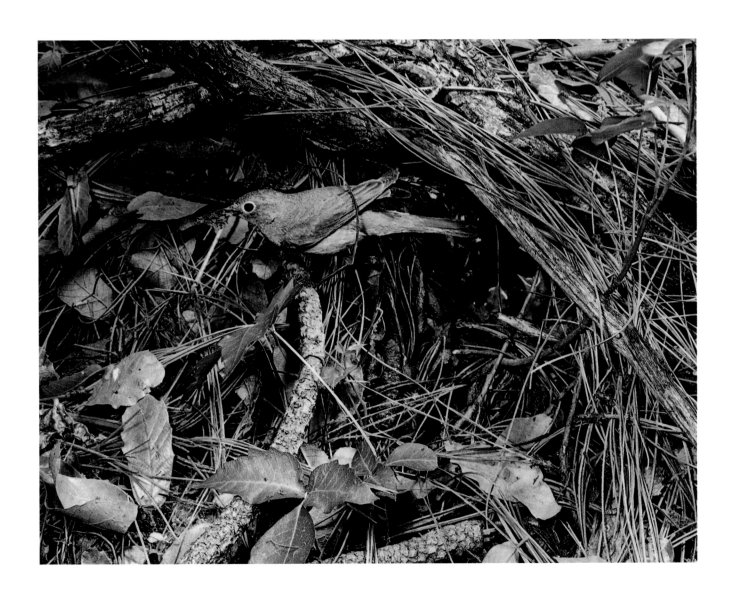

[48] VIRGINIA'S WARBLER

Vermivora virginiae

Near the Mexican border, in pine forests of the mountains,
a soft descending whistle announces the presence of the Olive Warbler.
This quiet bird is often easy to overlook as it forages high in the trees.
Adult males are distinctive, with a black mask on a bright copper-colored
head, but females and young males are not so contrasty, and their heads are
pale yellow. Nests of Olive Warblers tend to be difficult to observe, as they
are usually placed far out on a high branch of a pine. While most other
warblers from the southwestern mountains migrate to Mexico for the winter,
a few Olive Warblers always stay through the season in Arizona, associating
with little flocks of titmice and other songbirds in the oak woods of
the foothills. Many scientists believe that this enigmatic bird
is not really related to our other warblers, but its
exact relationships remain uncertain.

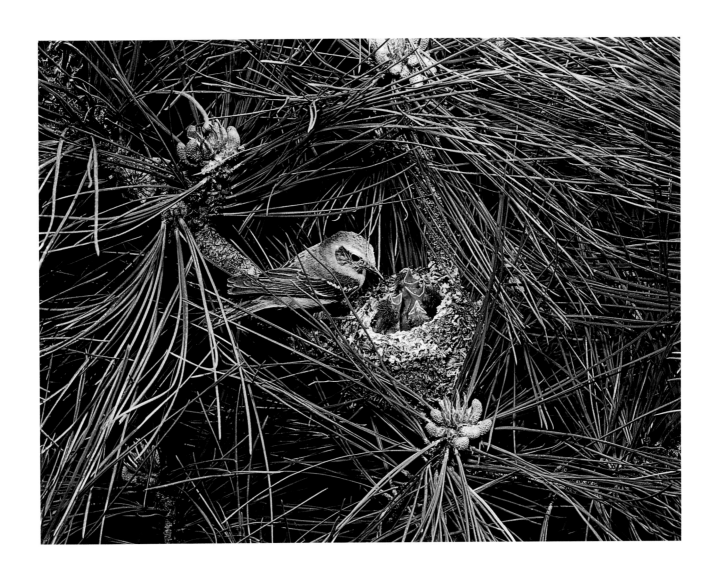

[49] OLIVE WARBLER

Peucedramus taeniatus

IN SUNNY PLACES around young second-growth woods
and forest edges, the flat buzzy song of the Blue-winged Warbler makes
a fitting accompaniment to hot summer mornings. This warbler spends the
summer in the eastern United States, with only a few reaching the southern
edge of Canada, and it winters in southern Mexico and Central America.
It places its nest on the ground or close to it, in a large grass clump under
shrubbery or among large weeds such as goldenrod. Because it thrives
in rather open habitats, the Blue-wing actually may have benefited from
the cutting of eastern forests in centuries past, and its numbers seem to be
holding up fairly well today. The blue on this warbler's wings is subtle,
and the bird is more readily recognized by its bright
yellow color and sharp black eye-stripe.

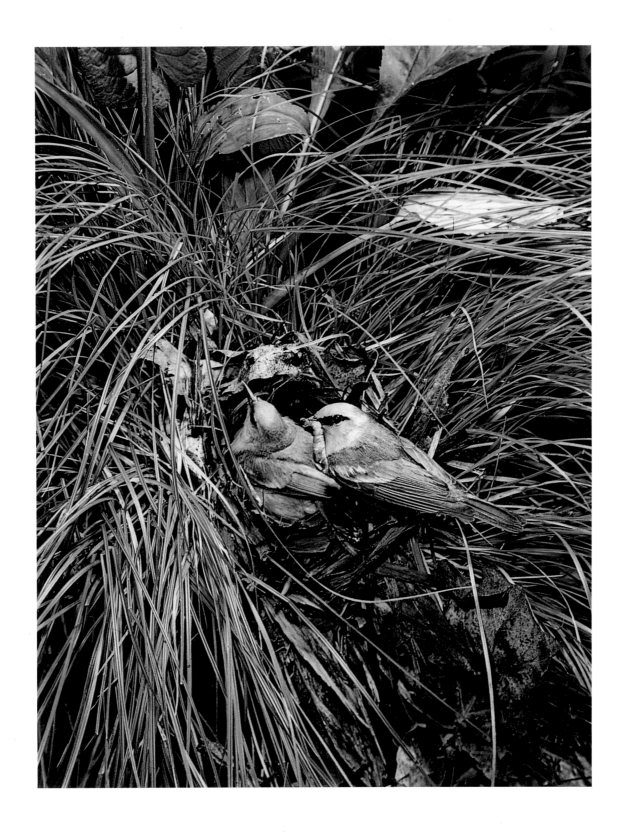

[50] BLUE-WINGED WARBLER

Vermivora pinus

A VOICE from the forest floor is the rolling, musical song
of the Kentucky Warbler. In moist deciduous woodlands of the East,
in leafy thickets near creeks and swamps, this elegant little warbler walks on
the ground. Even in the deep shadows of the undergrowth, it is easy to
recognize if it is glimpsed: its bold yellow "spectacles" are set off
by patches of black on the forehead and face, making a diagnostic pattern.
Kentucky Warblers stick to the forest interior both on their nesting grounds
and on their winter range in the tropics, from southern Mexico to
northern South America. This preference carries a price: unlike some
other warblers, which can adapt readily to second growth and cut-over
woods, Kentucky Warblers are disappearing along with
the forests that they require.

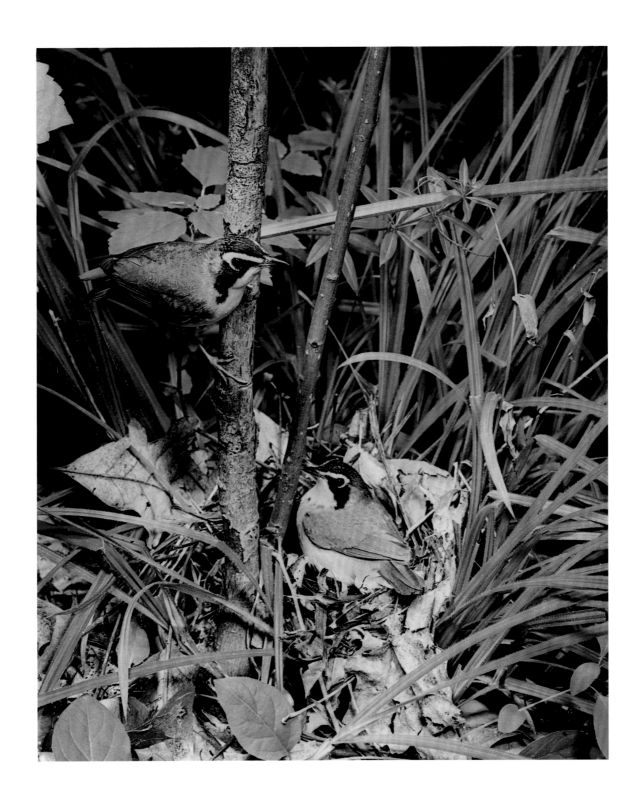

[51] KENTUCKY WARBLER

Oporornis formosus

A TAME and confiding little bird, the Chipping Sparrow

is found in backyards and farmland from coast to coast. Everywhere it is

recognized by its rusty-brown cap, black stripe through the eyes, and plain

gray chest. Its name might refer to its common callnote – a *chip* with a thin,

dry sound – or to its song, a series of chips run together into a buzzy trill

or rattle. In wild areas, the Chipping Sparrow usually places its nest low in

a dense spruce, pine, or other conifer, but in suburban settings it may nest

in rosebushes or other garden plants. This bird is only a short-distance

migrant, spending the winter in the southern United States and Mexico.

Although its nest is often parasitized by the Brown-headed Cowbird,

the Chipping Sparrow seems to be maintaining

a healthy population level.

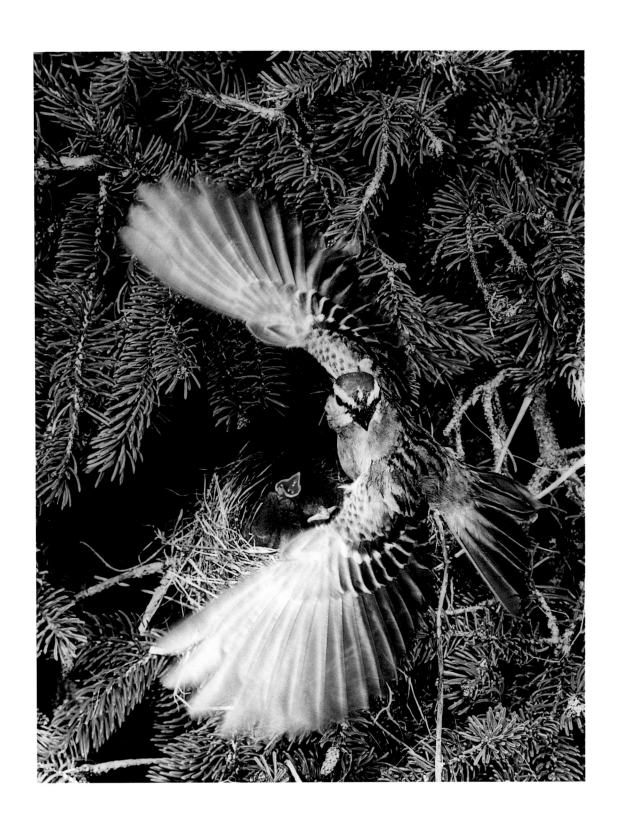

[52] CHIPPING SPARROW

Spizella passerina

SOME WOULD CALL this bird "the king of the sparrows."
It is a regal little bird, elegance in miniature, distinguished by its
striped crown. North to the edge of the tundra in Canada and Alaska,
and up to timberline in the mountains of the West, male White-crowns
perch on exposed twigs to sing their musical whistled and trilled songs
in summer. The females build the nests – which may be either on
the ground in a sheltered spot or up in a low shrub – and they incubate
the brown-spotted eggs; both parents help to feed the young birds.
Like some other widespread birds, White-crowned Sparrows have regional
variations in color. Those that nest in eastern Canada and in the high
mountains of the West are known by the concentration
of black feathers in front of the eyes, as shown
by the bird in this photograph.

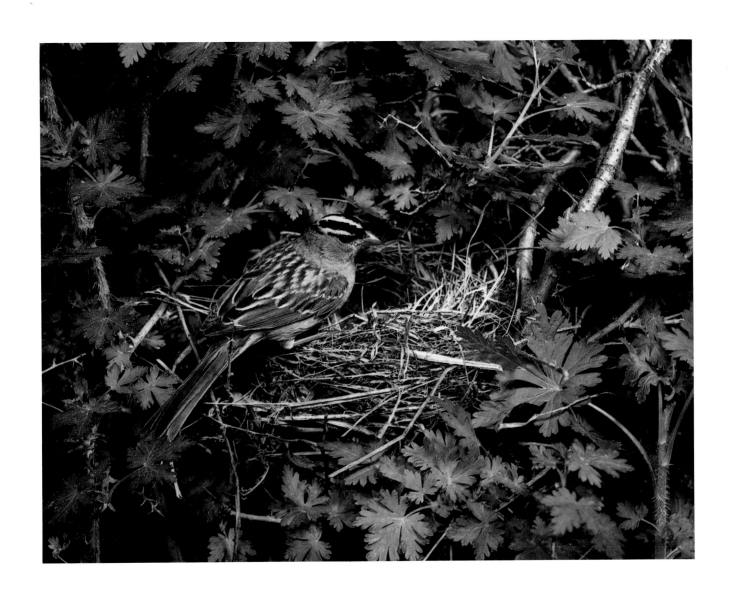

[53] WHITE-CROWNED SPARROW

Zonotrichia leucophrys

AMONG THE most attractive and distinctive of our native sparrows,
the Lark Sparrow is known by its harlequin face pattern and the bold
white corners on its tail. Living mainly in the West and Midwest, it favors
dry country, especially where thickets stand close to areas of bare ground
or short grass. Unlike some of its relatives, the Lark Sparrow is usually easy
to observe; it forages on open ground, perches up in the open to sing its
disorganized buzzes and trills, and gives a sharp metallic chip note as
it flies overhead. Its nest may be up in a low shrub, but more often
it is on the ground among dry weeds. Lark Sparrows were once more
common in the East, but in recent decades they have disappeared
from many former haunts east of the Mississippi River.

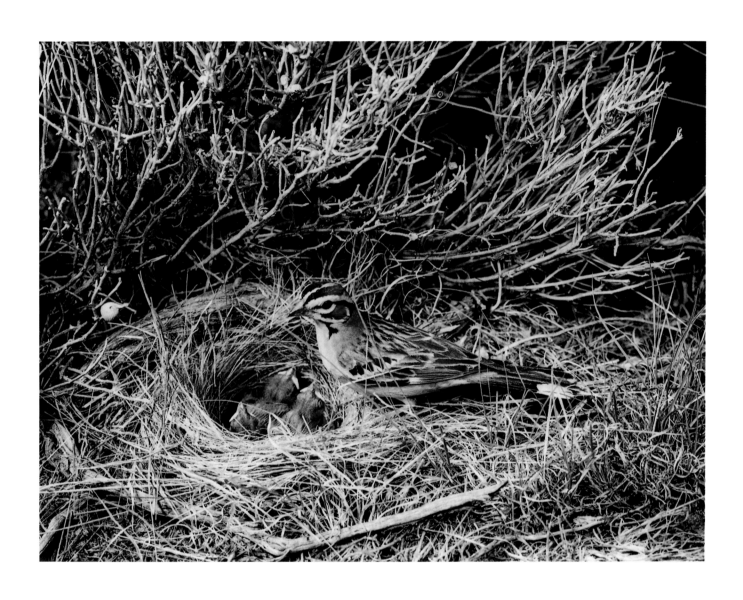

[54] LARK SPARROW

Chondestes grammacus

In dry country near the Rio Grande in southern Texas, spring mornings often resound with a distinctive birdsong, a dry metallic trill speeding up to a rattle. The singer is the Olive Sparrow, a tropical species that crosses the border only in this region. An observer who watches patiently along the edges of thickets will be rewarded with glimpses of a rather plain bird, dull olive above and pale gray below, with distinct brown head stripes. Olive Sparrows are permanent residents in Texas, living in pairs all year in native brushlands and riverside woods. They build their bulky nests of twigs and weeds close to the ground in a shrub or cactus. Most of their habitat in Texas has been cleared to make way for agriculture or housing, but the birds remain numerous where the native plant life is protected in parks or wildlife refuges.

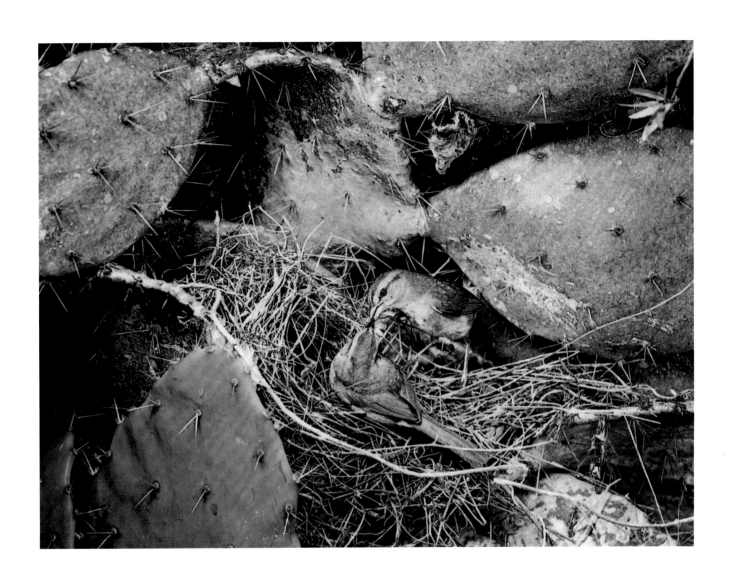

[55] OLIVE SPARROW

Arremonops rufivirgatus

SMALL AND unassuming, easily overlooked, this bird
is among the most widespread of our native sparrows. Its summer range
stretches from the shores of the Arctic Ocean to the mountains of Mexico,
and from the Great Plains to coastal salt marshes. Over this wide
distribution there are many local variations in appearance, from large and
pale to small and dark, but most forms are heavily striped like the bird
shown here. Savannah Sparrows live in habitats that are open to the sky:
prairies, farm fields, marshes, beach dunes. They almost always choose
nest sites on the ground, and usually they have dry grass pulled over
to form a canopy or cover above the nest, making it most inconspicuous.
Although the species as a whole is still abundant, some of the distinctive
races living in coastal marshes are vulnerable
to destruction of their habitat.

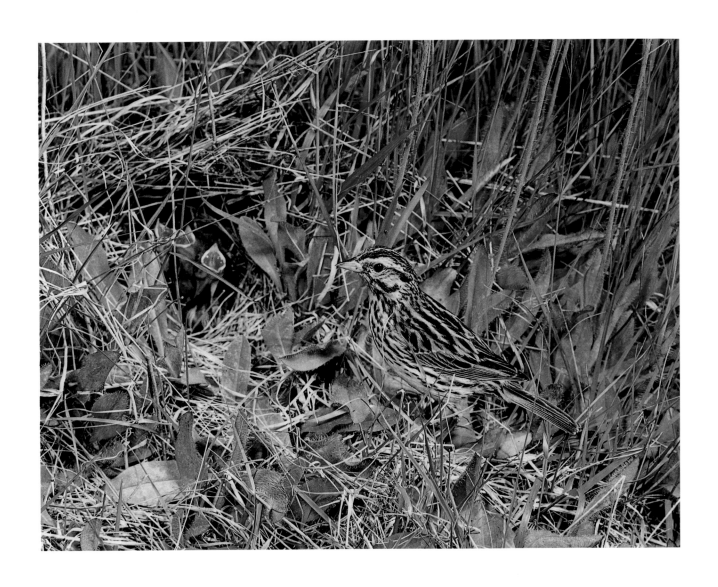

[56] SAVANNAH SPARROW

Passerculus sandwichensis

When the first big herds of beef cattle were brought
to the Southwest in the late 1800s, no one guessed that this rugged-looking
land would prove so vulnerable to the effects of grazing.
But within a few years, the luxuriant grass cover was gone, and with it
some of the birds that lived there. The Rufous-winged Sparrow, for example,
dropped out of sight for almost fifty years, until a few were discovered near
Tucson in the 1930s. Today the bird is found at many scattered points
in southern Arizona and northwestern Mexico, but it probably
will never return to its historical abundance.
Rufous-winged Sparrows live year-round in localized colonies
in desert grassland. The metallic trilling songs of the males are often heard
in late summer, and the birds usually begin breeding after the onset
of the summer rains, placing their nests among
the branches of desert shrubs or cactus.

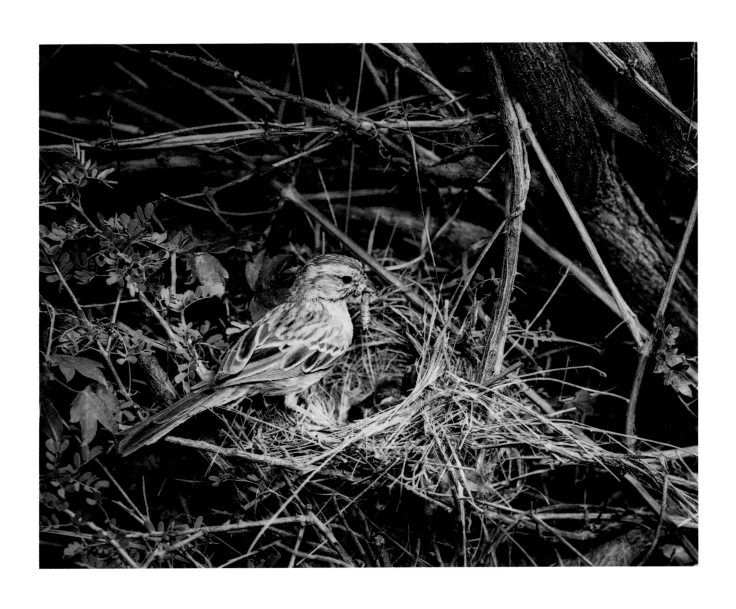

[57] RUFOUS-WINGED SPARROW

Aimophila carpalis

NATIONAL PRIDE may come into play here, but many Canadians would insist that this bird sings *Oh sweet Canada-Canada-Canada.* Such a refrain would be appropriate: this is a summer bird of the northern forest, widely distributed across Canada and parts of the northeastern United States. It builds its nest on the ground, hidden among fallen leaves, under the shelter of shrubs or dense ground cover. In autumn, White-throated Sparrows drift southward, becoming common throughout the eastern states and locally farther west. Their winter flocks forage on the ground in forest and in well-wooded city parks and gardens, and they will come to bird-feeders in yards that have plenty of shrubs or other low cover. Although these birds always have the trademark white throat, the stripes on the heads of adults may be either white or tan.

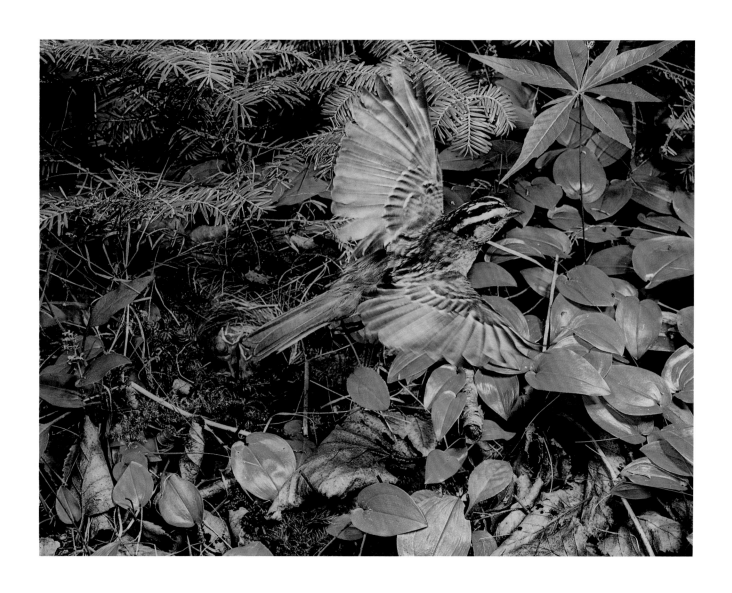

[58] WHITE-THROATED SPARROW

Zonotrichia albicollis

WHERE DENSE RANKS of cattails stand in shallow water,
anywhere across the northeastern states and much of Canada,
one may hear the slow musical trill of the Swamp Sparrow. Seeing the bird
is often more of a challenge: it spends much of its time down in the marsh
growth, hidden from view. When it does perch up in the open, it is known
by the rich chestnut-brown on its wings and cap, contrasting with the gray
of its face and chest. The Swamp Sparrow usually builds its bulky nest
directly over the water, lashed to standing reeds, cattails, or willow stems.
Like many other marsh birds, it has become less numerous as wetland areas
throughout North America have been drained. One very localized race,
living in salt marshes on the central Atlantic Coast,
is especially vulnerable to loss of habitat.

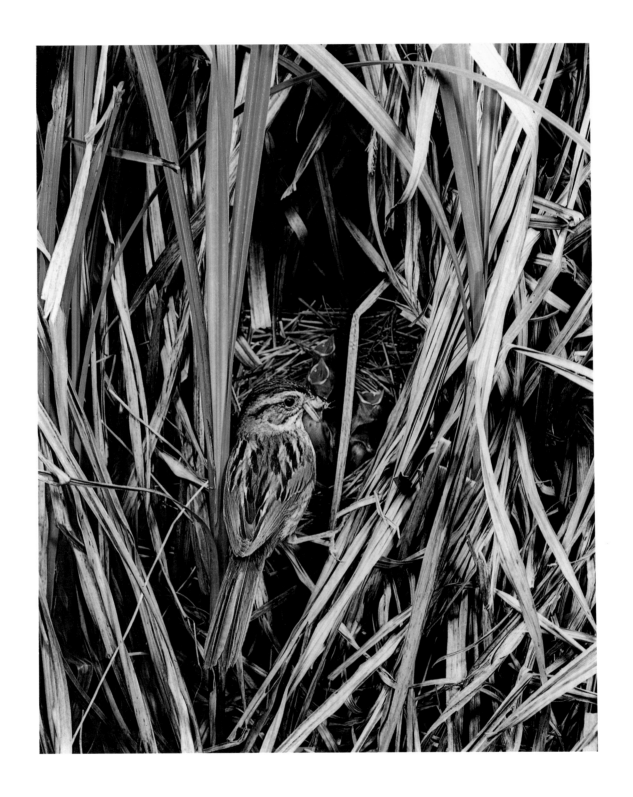

[59] SWAMP SPARROW

Melospiza georgiana

ON HOT SUMMER afternoons, when other songbirds have fallen silent,
the plaintive whistles of the Field Sparrow may still be heard in open country.
Despite its name, this sparrow is seldom encountered in fields of short grass;
it prefers old fields grown up to bushes and tall weeds, tangled thickets,
or the edges of woods. A small sparrow with a relatively long tail for its size,
it is recognized by its pink bill and rusty-brown cap. The lack of strong
markings on its face gives it a rather blank or innocent expression.
Field Sparrows are widespread in summer east of the Rocky Mountains,
vacating the northern part of their range in winter. They build their nests
on the ground in clumps of grass, or among the lower stems of dense
shrubs. Although Field Sparrows are still reasonably numerous,
their numbers have been declining in recent decades.

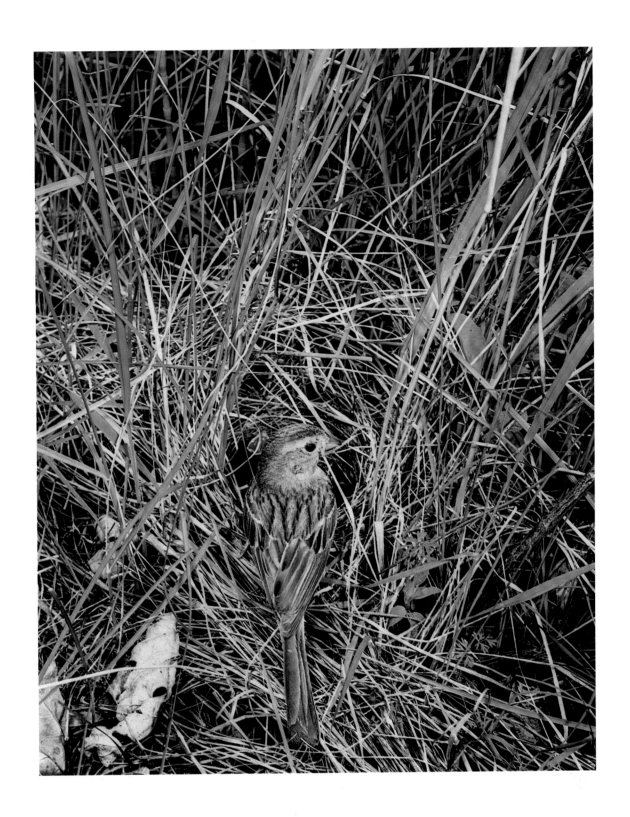

[60] FIELD SPARROW

Spizella pusilla

61. EASTERN KINGBIRD. *Tyrannus tyrannus.* With sputtering cries, the kingbird flies out to drive away any other birds that venture too near its nest – even much larger birds, such as crows or hawks. This bold behavior inspired the name for not only this species, but its whole family, the tyrant flycatchers. Recognized by the white band at the tip of its tail, the Eastern Kingbird occurs widely in summer east of the Rocky Mountains, and locally farther west. For the winter it travels to South America, where flocks live along lowland rivers east of the Andes.

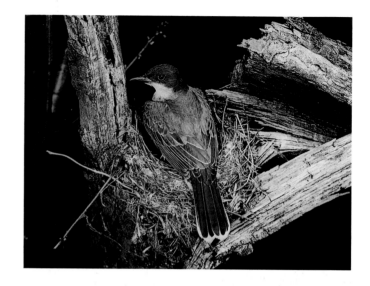

62. ASH-THROATED FLYCATCHER. *Myiarchus cinerascens.* In dry country of the western states, this bird has a wide distribution in summer. Although it is pale overall, with brownish gray on its back and only touches of light yellow below, it shows flashes of bright reddish-brown in its wings and tail when it flies. Ash-throated Flycatchers nest in holes, usually cavities in trees or old woodpecker holes in giant cacti, as shown here. They will also accept birdhouses, and in some regions they are quick to move into houses put up for bluebirds, which happen to like nest sites of the same size.

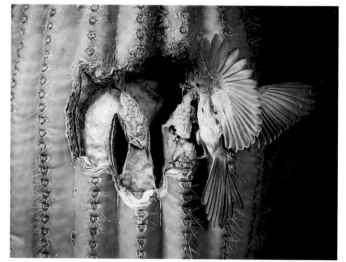

63. BROWN-CRESTED FLYCATCHER. *Myiarchus tyrannulus.* Widespread in the American tropics, this big flycatcher crosses the border into the southwestern states in summer, mainly in Texas and Arizona. Its habitat there is variable, from shady groves along rivers to stands of giant saguaro cactus in the desert; the choice is dictated by the presence of nest sites: old woodpecker holes or large natural hollows in the cacti or the trees. Although the Ash-throated Flycatcher is very similar in color, the Brown-crested can be identified by its larger size, more obvious shaggy-headed look, much heavier bill, and louder, more arresting calls.

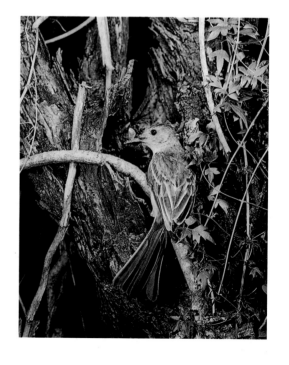

64. DUSKY FLYCATCHER. *Empidonax oberholseri.* Among dedicated bird watchers, there are actually standing jokes about the eleven little Empidonax flycatchers and how hard it is to tell them apart by sight. But the flycatchers themselves are never confused: each kind sings a different song and summers in a different habitat. In the mountainous West, the Dusky Flycatcher looks almost identical to two others, Gray and Hammond's flycatchers. However, the Hammond's nests in conifers of the highest elevations, while the Gray nests in valley sagebrush flats; the Dusky lives at intermediate levels, and often nests in deciduous trees.

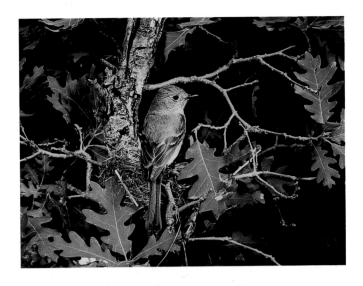

65. ALDER FLYCATCHER. *Empidonax alnorum.* In the long twilight of summer evenings in the far north, the Alder Flycatcher sings a buzzy *zee-BEE-oh* from alder thickets around streams and bogs. Until the 1960s, this bird was classified as part of a species called Traill's Flycatcher. Field studies proved that "Traill's" was really two species, including also the Willow Flycatcher, which sings a quick *FITZbew* from willow groves along rivers, mainly to the south of the Canadian border. The distinction is an important one: populations of Alder Flycatchers are doing fairly well, but Willow Flycatchers are declining in numbers and are considered endangered in parts of the West.

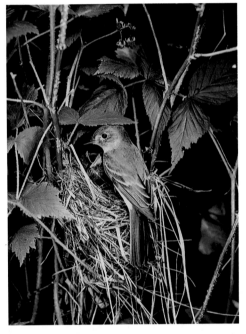

66. WESTERN WOOD-PEWEE. *Contopus sordidulus.* Although it is plain and gray, this little flycatcher is significant for sheer numbers. In some places in the western states, the Western Wood-Pewee is among the most common summer birds in the big trees along rivers and canyons. There it builds its nest on a high branch, decorating the outside with gray moss and lichens. Mostly lacking obvious markings, except for pale wing-bars and a touch of color on its bill, this bird looks very much like the Eastern Wood-Pewee, found from the Great Plains eastward. Its voice, a nasal, buzzy *pzeeyeer,* distinguishes the western species.

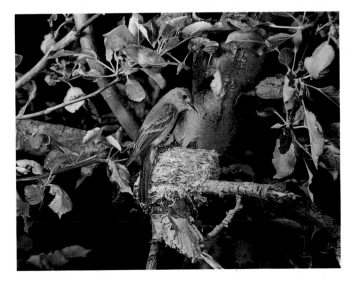

67. EASTERN PHOEBE. *Sayornis phoebe.* At the end of winter in the Northeast, when the buds on the trees are just swelling into leaf, a burry *fee-bee* call comes from the streamside woods. Northerners welcome the return of the Phoebe as a sure sign of spring. This confiding little flycatcher is easily recognized by its voice and by the way it gently wags its tail while perched. Historically it built its mud-based nest against an overhanging streambank or low cliff, but it has adapted to mankind's additions to the landscape and now often nests under bridges or under the eaves of houses.

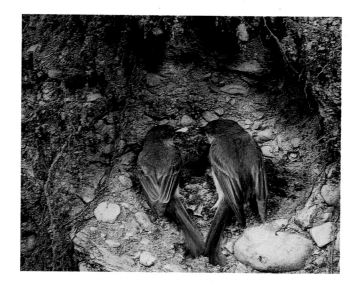

68. SEDGE WREN. *Cistothorus platensis.* Often overlooked, the Sedge Wren slips about furtively in the grassy margins of marshes or in damp meadows, usually staying low in the grass. Only in the nesting season will it climb a stem to deliver a stuttering, rattling song. Although its range stretches over much of the East, it is scarce or erratic in many regions. To add to its aura of mystery, sometimes this wren will arrive in a locale and start nesting in late summer, after bird-watching activity has waned for the season. In recent decades, Sedge Wren populations have been declining, but the reasons are not well understood.

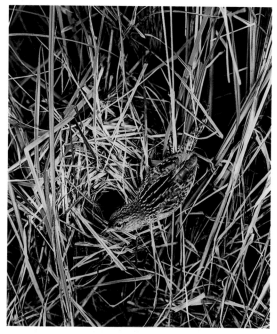

69. ROCK WREN. *Salpinctes obsoletus.* In arid zones of the West, in barren badlands where few other birds can make a living, the ringing call of the Rock Wren echoes across the dry slopes. This pallid wren sometimes lives in places where there are hardly any plants at all. There it hops and scurries about, probing in rock crevices with its long bill in search of insects and spiders, bobbing up and down when it pauses to look around. The Rock Wren's nest, well hidden among boulders, is sometimes betrayed by the bird's odd habit of laying out a "front porch" of pebbles in front of the entrance.

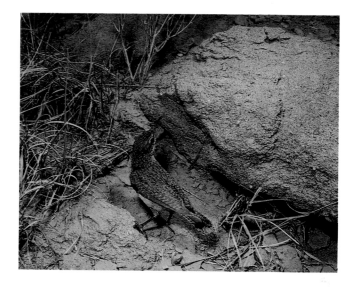

70. GOLDEN-CROWNED KINGLET. *Regulus satrapa.* Among the smallest of all songbirds, barely bigger than hummingbirds, kinglets are tiny birdlets that flit hyperactively through the trees, flicking their wings open and shut in bursts of nervous energy. This species, the Golden-crown, lives all year in dense evergreens. Often it forages high above the ground, making it hard to see the black-bordered yellow crown patch, or even hard to see the bird itself. Bird watchers may locate the Golden-crowned Kinglet in spruce groves by listening for its high-pitched, lisping calls, given in trios, *see-see-see.*

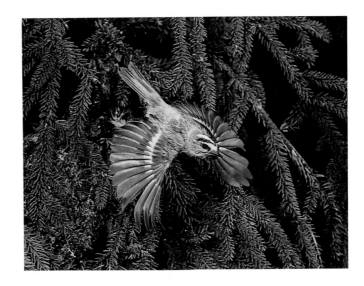

71. RUBY-CROWNED KINGLET. *Regulus calendula.* Despite the name, there is nothing kingly about these tiny birds – except that they wear bright "crowns," patches of contrasting color on their heads. On the Ruby-crowned Kinglet, only the male has this color, and it is usually obscured by surrounding gray feathers. Nesting in conifer forests of the North and the high mountains in summer, the Ruby-crown moves into southern lowlands in winter, to flit about in thickets and woods. For such small birds, kinglets seem remarkable in their ability to withstand cold temperatures, but sometimes many will be killed by exceptionally harsh winter weather.

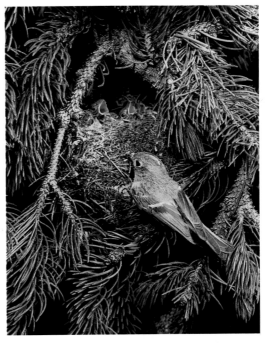

72. BLACK-TAILED GNATCATCHER. *Polioptila melanura.* Related to the kinglets, gnatcatchers are almost as small-bodied, but they have longer tails which they flip about expressively as they hop through the foliage. Black-tailed Gnatcatchers are birds of the Southwest, found from the California deserts to southern Texas. They live in pairs all year in very dry country, including desert areas with nothing more than small and scattered bushes. Both sexes are gray above and white below, with very narrow white edges on the black tail. Only in the nesting season does the male develop the distinctive black cap seen in this portrait.

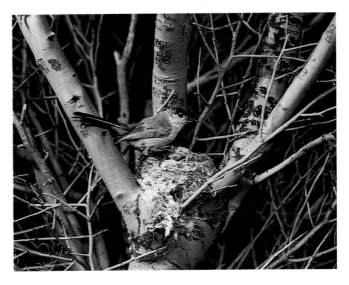

73. BLUE-GRAY GNATCATCHER. *Polioptila caerulea.* A tiny, active sprite with a long tail, this bird can be hard to spot in eastern forests as it flits about the treetops. It may be easier to see in the West, where it often frequents scrubby oaks or nests in low junipers, like the bird seen here. In winter it moves to the southern tier of states, where its distinctive whining callnotes can be heard from thickets and streamside woods. Although the Blue-gray Gnatcatcher has lost some habitat with the cutting of forests, it has also managed to extend its range northward in recent decades.

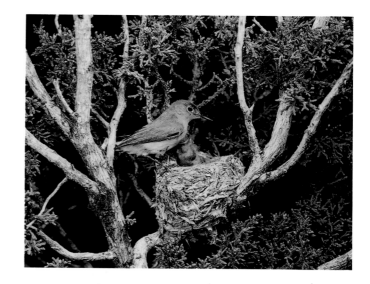

74. SWAINSON'S THRUSH. *Catharus ustulatus.* From southern Alaska to northern Maine, and well southward in the West, this thrush is common in summer. Keeping to the forest understory, it is easily overlooked, but its song is heard often: clear musical phrases that irregularly climb the scale. Also heard often is its soft callnote, like a muted bell or like a drop of water falling into a woodland pool. When this bird migrates between the north woods and its tropical winter range, it flies mostly at night. Bird watchers who listen outside at night in spring or fall may hear the calls of Swainson's Thrushes passing swiftly overhead in the darkness.

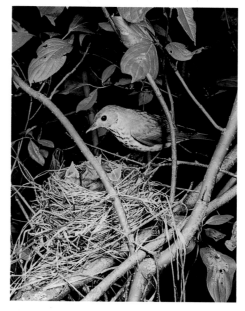

75. EASTERN BLUEBIRD. *Sialia sialis.* This is one of the best-loved birds of the eastern states, carrying sky-blue on its back and earth-toned russet on its chest, singing with soft musical notes. Earlier in the twentieth century, the Eastern Bluebird was disappearing from many regions. Because it nests in holes in trees, it was losing nest sites: old dead trees were being cut down, and aggressive Starlings and House Sparrows were competing for the remaining spots. Fortunately, by putting up tens of thousands of bluebird houses, conservationists have been able to remedy this shortage of sites and bring the bluebird back to healthy numbers.

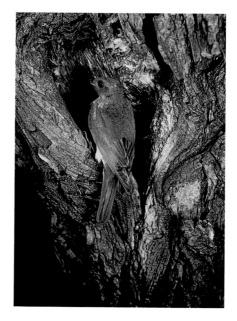

76. WESTERN BLUEBIRD. *Sialia mexicana.* Richly colored is this bluebird of the western states. The purplish-blue of the male is set off by patches of chestnut-brown on his chest and usually on his back. Females are more softly colored, gray with tinges of blue and brown. Widespread in summer, Western Bluebirds gather in flocks in winter to wander the Southwest and the Pacific Coast. Their natural nest sites, in cavities in dead trees, have become harder to find, as forests have been cut and competitors such as Starlings have moved in. Despite efforts to supply birdhouses for them, Western Bluebirds have been declining over much of their range.

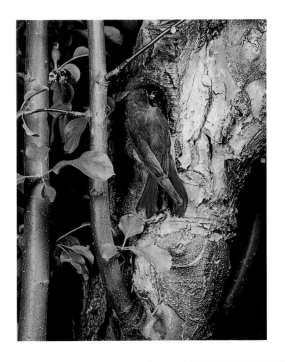

77. AUDUBON'S HERMIT THRUSH. *Catharus guttatus auduboni.* Bird watchers who travel are often impressed by how birds vary from place to place. Someone who knows the Hermit Thrush from the Northeast may be surprised by its appearance in the Rocky Mountains, where it is much larger and paler. Its habits also vary. In the Rockies, it usually builds its nest up in an evergreen, as seen here, while northeastern Hermit Thrushes often nest on the ground. Despite these differences, these forms are classified under the same species. The Rocky Mountain bird is considered a separate subspecies, or race, Audubon's Hermit Thrush, named for the pioneer bird painter.

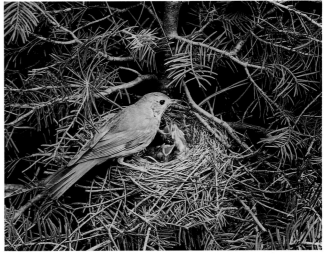

78. AMERICAN ROBIN. *Turdus migratorius.* Homesick Englishmen, settling in North America centuries ago, named this bird "Robin" after another orange-breasted bird they had known at home. But while the European Robin is a small, dainty thrush, our American Robin – only distantly related – is a big, bold, strident, striking bird. Familiar in gardens and parks over much of our continent, the American Robin builds its nest in shade trees or under the eaves of houses. Typically it uses mud as a nest foundation, and then adds fine grasses as a nest lining on which to lay its four eggs of robin's-egg blue.

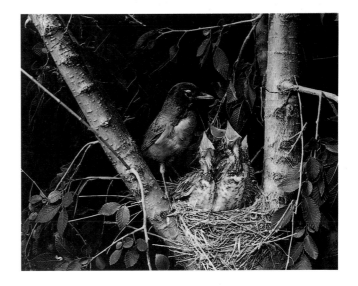

79. CURVE-BILLED THRASHER. *Toxostoma curvirostre.* One of the best-known birdcalls in the desert Southwest is the arresting *whit-wheet!* of the Curve-billed Thrasher. From Arizona to Texas, and north as far as southeastern Colorado, this is a typical bird of the arid lowlands. It is most likely to be seen where cholla cactus grows: usually it builds its bulky, twiggy nest among the spiny arms of the cholla, like the bird shown here. Although Curve-billed Thrashers are still very common in parts of the Southwest, apparently they are declining in numbers in Texas.

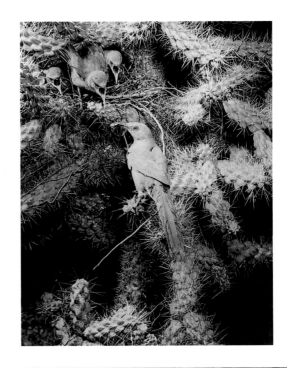

80. WARBLING VIREO. *Vireo gilvus.* From coast to coast, in woodland edges or in shade trees in towns, the languid warble of this vireo makes background music for warm summer days. The bird itself can be hard to spot, as it often keeps to the dense foliage. When it comes out in the open, it is recognized by its overall gray color and its wide-eyed look, with wide pale eyebrows above its beady black eyes. Like other members of its family, the Warbling Vireo builds a neat cup-shaped nest, suspended by its edges from a forked twig.

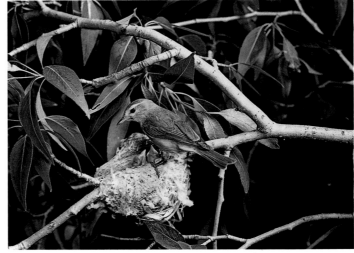

81. RED-EYED VIREO. *Vireo olivaceus.* Although it often goes unseen, this species is among the most numerous summer birds in eastern forests. Anyone who knows its song will confirm this: the vireo sings tirelessly in spring and summer, even on hot afternoons, a seemingly endless series of short, monotonous phrases. The red color of its eyes is hard to see at a distance; it is better known by its head pattern, with black stripes setting off white eyebrows and gray crown. Although Red-eyed Vireos are still common, they are vulnerable to loss of forest habitat, both in our area and on their wintering grounds in South America.

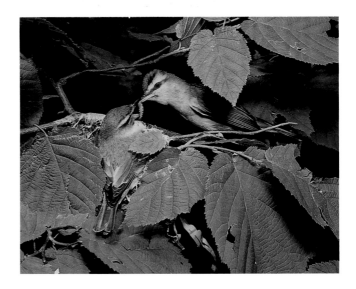

82. BELL'S VIREO. *Vireo bellii.* This bird's appearance is plain and pale, and its song is only a jumble: disorganized notes with a clinking sound, as if it were trying to sing with a mouthful of marbles. But even if it seems unimpressive, Bell's Vireo is important as an indicator of the quality of streamside environments in parts of the West and Midwest. Living in thickets along rivers, this vireo has become scarce in many areas recently – especially in California, where it is now considered an endangered species. Evidently, with the breakup of streamside habitats, the vireo becomes too vulnerable to cowbirds laying eggs in its nest.

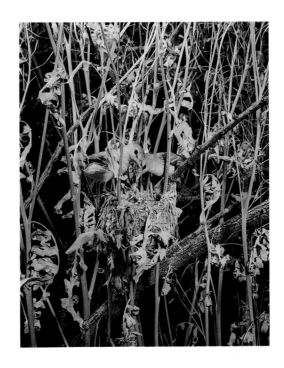

83. WILSON'S WARBLER. *Wilsonia pusilla.* We met the Wilson's Warbler earlier, a representative of a tribe of small, colorful, active birds. Eliot Porter was particularly enchanted with the warblers, and he managed to photograph most of the North American species at their nests, a feat that few others have approached. Finding the warblers is becoming even more of a challenge: with destruction of their habitat and a variety of other problems, many kinds are declining in numbers. One that is still doing well in most areas is the Wilson's Warbler, a bright yellow, black-capped sprite of the willow groves and alder thickets.

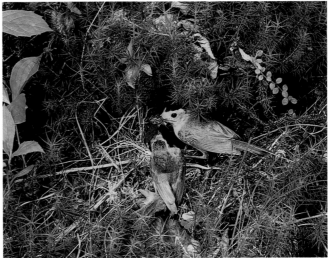

84. PRAIRIE WARBLER. *Dendroica discolor.* Thin wiry buzzes, in a series climbing the scale, announce the Prairie Warbler on its summer range. If this bird actually lived on open prairies it would be easy to observe, but its real habitat consists of dense low growth such as overgrown brushy thickets or stands of young pines in the eastern states. It adopts low cover of a different sort in Florida, where it often nests in coastal mangrove swamps. Everywhere it is known by its black-on-yellow face pattern and its constant tail-wagging. In recent years the bird has decreased in numbers, probably because of changes in habitat.

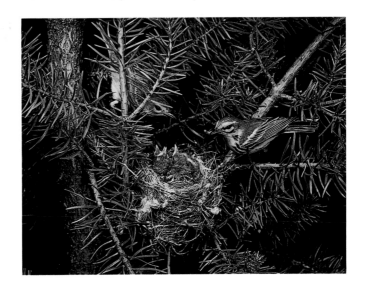

85. BLACK-THROATED BLUE WARBLER (MALE).
Dendroica caerulescens. Many of our warblers (and other songbirds)
were named for the colors and patterns of the males only. A case
in point is the Black-throated Blue Warbler, in which only the male
wears black, white, and dark iridescent blue. Despite his striking
pattern, he can be surprisingly inconspicuous in the forest shadows.
In southeastern Canada and the northeastern United States, Black-
throated Blues spend the summer in cool woods of maple, beech,
and hemlock, especially where rhododendrons make up the under-
story. They have become less numerous as forests have been cut
down or broken up into smaller fragments.

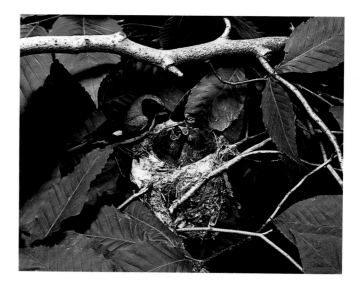

86. BLACK-THROATED BLUE WARBLER (FEMALE).
Dendroica caerulescens. Often, female songbirds are less brightly
colored than males. The female Black-throated Blue Warbler, for
example, has no black and only a tinge of blue; she is rather plain,
best recognized by the white checkmark on her wing. But she has
a good reason for duller colors. As with many warblers, the female
Black-throated Blue alone builds the nest and incubates the eggs,
and her subtle hues make her less noticeable during this vulnerable
period. Only when the eggs have hatched, and the demanding
young need to be fed, does the male pitch in to help.

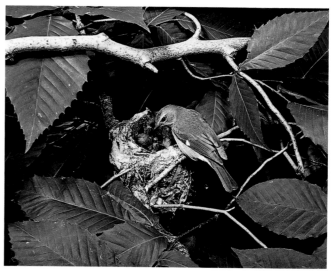

87. BLACKPOLL WARBLER. *Dendroica striata.* One of the
most amazing migrants among our small songbirds, the Blackpoll
Warbler may travel in fall from the coast of New England to northern
South America in one long, continuous flight, perhaps flying over
water for more than three days and nights. On its return in spring
it takes a less arduous route, island-hopping north to Florida, on its
way to the spruce forests of Canada and Alaska. Male Blackpolls in
spring are readily identified by pattern, with black cap, white cheeks,
and streaked body. Before their fall journey, however, they molt into
a plainer greenish plumage.

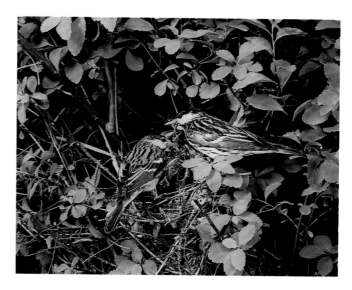

88. YELLOW WARBLER. *Dendroica petechia.* From Alaskan willow thickets to mangrove swamps along tropical coasts, and from New England gardens to riverside groves in California, this is one of our most widespread warblers in summer. Males are brilliant yellow all over, with blurry red stripes on the chest, while females are usually a duller and paler yellow. Cowbirds often lay eggs in these birds' nests, but at least in some regions, the Yellow Warblers have a defense: they will build a new nest bottom right over the cowbird eggs, and lay a new set of eggs of their own.

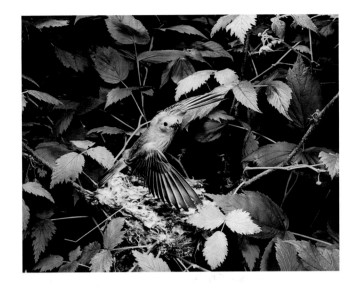

89. MYRTLE WARBLER. *Dendroica coronata coronata.* While most warblers head for the tropics in autumn, Myrtle Warblers remain abundant through winter in the Southeast, with a few surviving north to New England. The reason they can do so is implied by their name. This warbler is adapted to live on berries, and especially likes those of the wax myrtle, or bayberry. Where dense stands of wax myrtle grow along the southern Atlantic Coast, Myrtle Warblers flit through the bushes by the scores in winter, calling *check* as if to confirm their identity. Currently this bird is classified as the eastern form of a more widespread bird, Yellow-rumped Warbler.

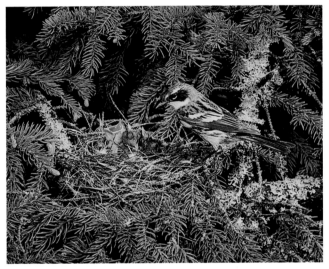

90. AUDUBON'S WARBLER. *Dendroica coronata auduboni.* The common winter warbler of the West, Audubon's is now considered to be a western form of the Yellow-rumped Warbler. It spends the summer in evergreen forests of the mountains and the Northwest, and winters in lowland valleys and along the Pacific Coast north to Seattle. Very similar to the Myrtle Warbler of the East, Audubon's is known by its less contrasting face pattern and its throat patch of yellow, not white. Both types of Yellow-rumped Warblers build cup-shaped nests on branches of spruce, fir, or other conifers.

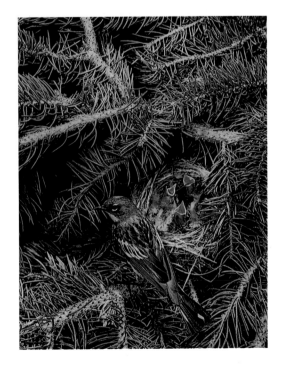

91. CAPE MAY WARBLER. *Dendroica tigrina.* Going to the West Indies for the winter is not a bad idea, especially for one whose summer home is in the north woods. The Cape May Warbler does this every year. During the winter months it is widespread around Caribbean islands and coastlines; it often forages around the crowns of palms, or visits flowers to sip nectar. For the summer it flies north to the spruce woods of eastern Canada and the extreme northern edge of the United States. On passage it might happen to pause at Cape May, New Jersey, for which the species was originally named.

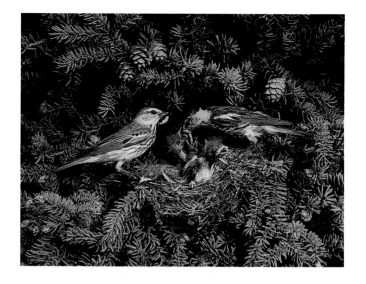

92. WORM-EATING WARBLER. *Helmitheros vermivorus.* The name of this warbler is not to be taken too seriously. The bird does not pull up earthworms; it does eat other "worms," mainly moth caterpillars, but no more so than many other birds. Worm-eating Warblers occur widely in summer in the eastern states. They live in the shady understory of deciduous woods, where they hop through thickets, using their rather long bills to probe in clusters of dead leaves. When they are seen well, their pattern of strong black stripes on a buffy-brown head renders them unmistakable.

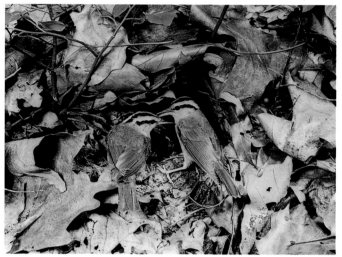

93. LUCY'S WARBLER. *Vermivora luciae.* Many of the warblers are impressive for their bright patterns or long migrations. This one is impressive for its surroundings: it is the only warbler to nest in arid zones of the desert Southwest. In groves of mesquites along dry arroyos, the sweet simple song of the Lucy's Warbler is a typical sound of early spring. Unlike most warblers, this species builds its nest in a sheltered spot inside a tree cavity or under a slab of loose bark. With the clearing of many old mesquite groves in the Southwest, Lucy's Warblers have undoubtedly become less numerous than they once were.

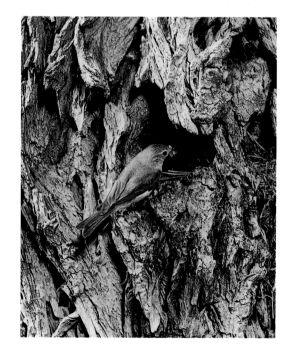

94. MOURNING WARBLER. *Oporornis philadelphia.* Three kinds of gray-hooded, olive-backed warblers skulk in the thickets and bramble patches of North America. Widely distributed in summer in eastern Canada and the northeastern United States is the Mourning Warbler, so named because the male's black throat once suggested someone dressed in mourning. The female, seen here, is lighter gray on the head, sometimes with a paler area around the eye. Wintering from Nicaragua to Ecuador, the Mourning Warbler moves north late in spring, passing through unseen after the shrubs in the forest undergrowth are in full leaf.

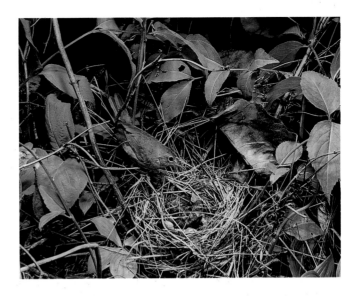

95. MACGILLIVRAY'S WARBLER. *Oporornis tolmiei.* A counterpart of the eastern Mourning Warbler, this bird spends the summer in the mountains and valleys of the western states and far western Canada. There it nests in dense low stands of alder, gooseberry, or other young trees or shrubs, generally keeping out of sight. When seen well, it can be separated from similar warblers by the sharp crescents of white above and below each eye. MacGillivray's Warbler has a short but rich song of quick rolling phrases, heard often in early summer. Only a short-distance migrant compared to its relatives, it winters most commonly in Mexico.

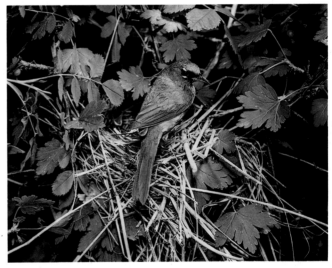

96. CONNECTICUT WARBLER. *Oporornis agilis.* Highly sought after by bird watchers, this is a scarce and elusive warbler, summering around bogs in central Canada and the northern Great Lakes states. It is only an uncommon bird of passage in Connecticut: like several other warblers, it was named for a place where it happened to be discovered during its migration. When foraging, the Connecticut Warbler walks on the ground with slow, deliberate steps, under dense thickets; this behavior makes it much harder to detect than those warblers that flit actively through the trees. Like many other migrants, this species is vulnerable to loss of habitat on its South American wintering grounds.

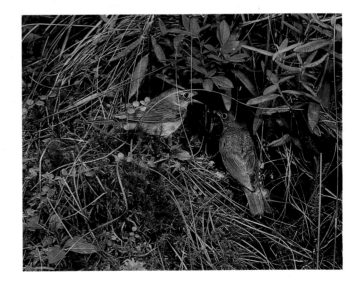

97. BLACK-AND-WHITE WARBLER. *Mniotilta varia.* This is the warbler that thinks it's a creeper, forever clambering about on trunks and limbs of trees. It is a widespread summer resident of the eastern United States and Canada, living mainly in deciduous woods, where it often hides its nest on the ground under a log or among roots. Although a couple of other warblers are patterned in black-and-white, the genuine Black-and-white Warbler is identified by the strong stripes on its head and, more importantly, by its tree-creeping behavior. In recent years, this distinctive bird has disappeared from some former parts of its range.

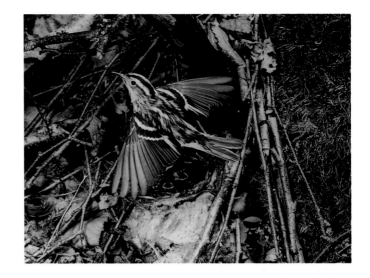

98. BLACK-THROATED GREEN WARBLER. *Dendroica virens.* While this warbler always can be recognized by its yellow face and olive-green back, the black throat advertised in the name is shown only by the adult male. The Black-throated Green Warbler is common in summer in evergreen forests east of the Rockies in Canada and the northeastern United States. Surprisingly, a separate population also nests in cypress swamps along the southern Atlantic Coast. In all of these areas, the males sing a distinctive song from high in the trees, a lazy, buzzy *zooo zee zoo-zoo zeee.*

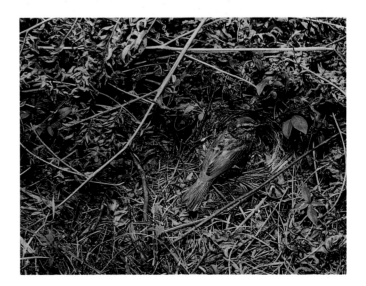

99. PALM WARBLER. *Dendroica palmarum.* In the shadows of the palms, during the winter months, this warbler hops about actively on beaches and lawns. In Florida and in many areas around the Caribbean, this is a characteristic winter bird. It is easily seen as it forages on open ground, and easily known by its constant habit of wagging its tail up and down. For the summer it moves to very different surroundings, the edges of bogs in northern forests. There its nest is usually well hidden, placed at the base of a small tree or tucked into a hummock of sphagnum moss on the ground.

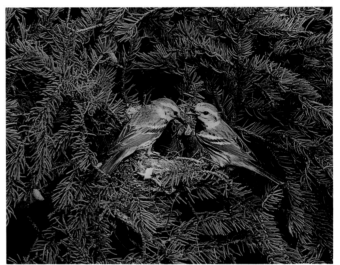

100. LOUISIANA WATERTHRUSH. *Seiurus motacilla.* Not related to the true thrushes, waterthrushes are really warblers that walk on the ground, wagging their hindquarters up and down in a conspicuous teetering motion. They are almost always found in wooded areas near water. This is the more southerly of the two species, nesting in the eastern states north to the Great Lakes and southern New England. A very early spring migrant, it arrives in the South from its Mexican wintering grounds before the end of March. Although the Louisiana Waterthrush is still reasonably common, it has undoubtedly lost ground with the cutting of forest along southern creeks and rivers.

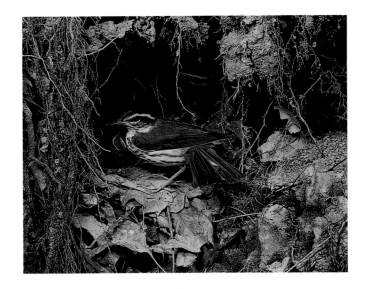

101. NORTHERN WATERTHRUSH. *Seiurus noveboracensis.* From Alaska to eastern Canada, and into the northern edge of the lower forty-eight states, this bird bobs and teeters along the edges of creeks, bogs, and ponds. If disturbed, it flies away along the shore, giving a loud metallic callnote. Its song is a series of emphatic notes, becoming faster and louder toward the end, as if the bird were impatient to finish. The two kinds of waterthrushes are very similar, but the Northern is much more widespread and numerous. It has a smaller bill and a less striking face pattern, and its eyebrows and underparts are sometimes yellow, not white.

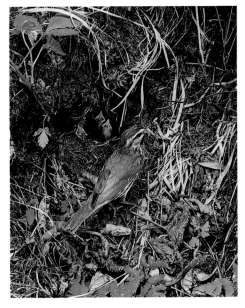

102. AMERICAN REDSTART. *Setophaga ruticilla.* Flitting about in the trees, holding its wings and tail partly spread as if to show off the patches of orange, the male American Redstart almost seems to be demanding attention. Anyone watching this warbler perform will understand why warblers, as a group, are sometimes called "the butterflies of the bird world." The summer range of the American Redstart is mainly in the eastern United States and southern Canada, but it is found locally over much of the West as well, nesting in leafy woods. Although it is still very common, its numbers apparently have been dropping in recent years.

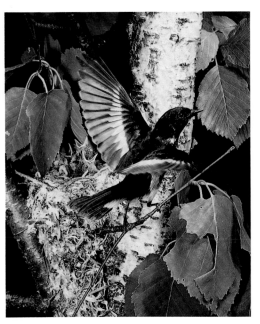

103. BLACK-THROATED GRAY WARBLER. *Dendroica nigrescens.* Attractive in monochrome is this warbler of the western foothills. Patterned in black, white, and gray, it shows no color except for a small spot of yellow near the eye. Its hoarse, buzzy songs are heard in dry woodlands of juniper and oak in summer, where the bird places its nest near the trunk of a tree among concealing foliage. For the winter, most Black-throated Grays go to western Mexico, but a few remain in the southwestern United States. Occasionally one will stray all the way east to the Atlantic Coast, creating excitement for bird watchers there.

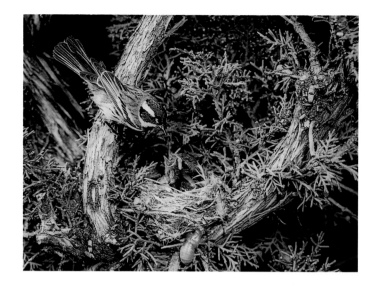

104. PAINTED REDSTART. *Myioborus pictus.* Many would nominate this species as the most beautiful of all the warblers. The northernmost representative of a tropical group, the Painted Redstart enters our area only in mountains near the Mexican border. There it seems to dance in the trees, turning this way and that, its wings and tail spread widely, showing off patches of white feathers against black. Both male and female show the striking pattern and the patch of red on the chest. They build their nest on the ground, usually in a protected nook in a steep hillside.

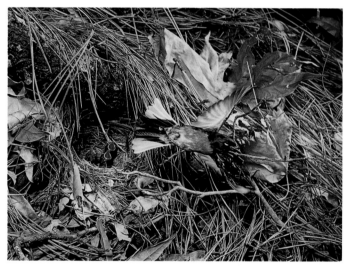

105. YELLOW-BREASTED CHAT. *Icteria virens.* The clown of the bird world, the chat almost seems to delight in playing the non-conformist. Usually it is heard before it is seen: an astonishing series of hoots, gurgles, whistles, and squawks, coming from the depths of a briar tangle. Eventually, as if to answer the riddle it has posed, the chat launches into the air and flops about above the thicket for a few seconds, singing all the while. Although the chat is usually classified as a warbler, it stretches the definition for that group. Found from coast to coast in summer, it is most numerous in the southern states.

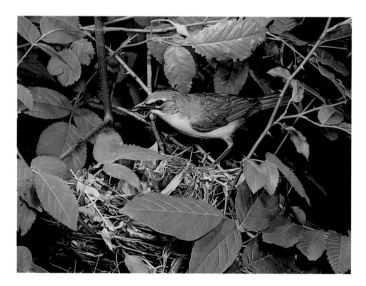

106. ROSE-BREASTED GROSBEAK. *Pheucticus ludovicianus.*
With the heart-shaped patch of rose-red on its chest, combined with
its strong black-and-white pattern, the male Rose-breasted Grosbeak
is unmistakable. However, it is often overlooked. Many easterners may
have this elegant bird in their neighborhoods in summer without
knowing it. This grosbeak favors groves of deciduous trees, where
it may stay out of sight among dense foliage of the upper branches.
The male sings with emphatic whistled phrases, somewhat like an
American Robin, but richer-toned and faster. Females, striped with
brown and white, are known by their thick pale bills and sharp
peek callnotes.

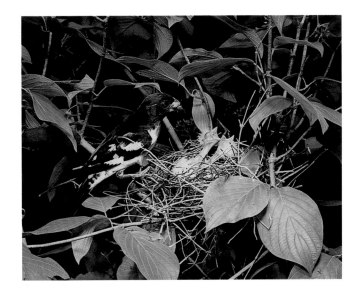

107. BLUE GROSBEAK. *Guiraca caerulea.* We have already met
the Blue Grosbeak, a chunky bird of southern thickets. The male
draws most of the attention, but the female is attractive in her own
right, a warm-brown bird with wing markings of subtle blue and
palest cinnamon. In the shelter of dense low cover she builds her
nest, a neat cup of grass and twigs, often decorated with odd items
such as small rags or pieces of snakeskin. She alone incubates the
four pale blue eggs, but the male will sometimes come to feed her
while she sits on the nest.

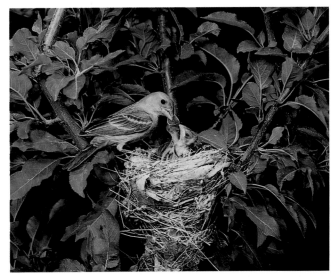

108. INDIGO BUNTING. *Passerina cyanea.* In some regions east
of the Great Plains, this little bunting is among the most abundant
songbirds of summer. The male Indigo Bunting, such a dark indigo-
blue that he may look black at a distance, sings bright quick phrases
from bush tops and wires along country roads and woodland edges.
His mate is pale brown, almost unmarked except for narrow streaks
on the chest. She typically stays out of sight during the nesting season.
Tending to her nest deep in the thickets, she leaves the male to patrol
the territory, singing to warn away real or imagined rivals.

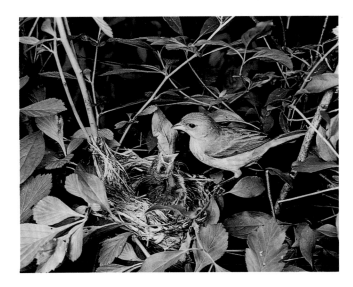

109. EASTERN TOWHEE. *Pipilo erythrophthalmus.* Easterners who live close to the woods may know this bird as "Chewink," an approximation of its common callnote. The Eastern Towhee is found widely east of the Rockies and north to extreme southern Canada. It is recognized by its solidly dark back (black or brown), its rusty-red sides, and the strip of white down its chest. In most regions, its eyes are red. Like other towhees, it seeks food by scratching with its feet among dead leaves on the forest floor. In recent years, populations of this towhee have dropped sharply in the Northeast, probably because of changes in habitat.

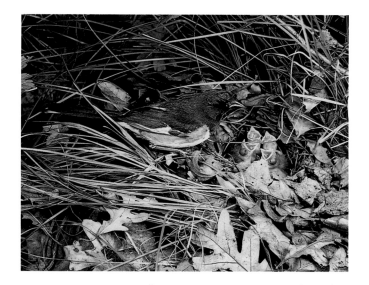

110. WHITE-EYED TOWHEE. *Pipilo erythrophthalmus alleni.* Towhees are variable in appearance, and this has led to differences in opinion as to how some local forms should be classified. In parts of the southeastern states, especially in Florida, the eyes of the Eastern Towhee are strikingly pale, giving the bird a stark, glaring expression. These White-eyed Towhees are very common in the undergrowth of some southern woods, especially in scrubby palmettos. Often very elusive, they hide in the thickets, making callnotes and songs that seem shorter and higher-pitched than those of their close relatives to the north.

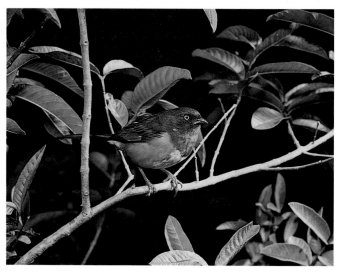

111. CANYON TOWHEE. *Pipilo fuscus.* Some related species show brighter colors or stronger patterns, but none seems to show more personality than this plain brown bird. In dry open country of the Southwest, Canyon Towhees live in pairs at all seasons. They often seem rather tame, running about on the ground in picnic areas and campgrounds, foraging under parked cars, squabbling with sparrows over minor rivalries, calling a musical *cheeyilp*. In spring, the males perch higher in the bushes to sing a simple but melodious chippering trill. Canyon Towhees are remarkably sedentary, almost never moving away from their permanent territories.

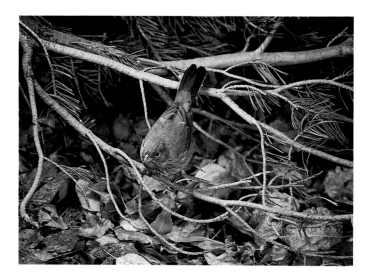

112. GRASSHOPPER SPARROW. *Ammodramus savannarum.*
Waiting patiently near a nest, Eliot Porter was able to take a portrait
of this bird actually eating a grasshopper. However, the bird was
named not for its diet but for its song, a flat dry buzz like the sound
of an insect. The Grasshopper Sparrow is found from coast to coast
in summer, in open weedy fields. It often hides in the grass; when
seen, it is known by its plain buffy face and chest and the two black-
ish stripes on its head. As grasslands have been broken up for farming
or development, the Grasshopper Sparrow has become scarcer in
many areas.

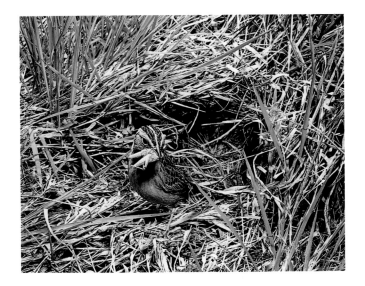

113. BLACK-THROATED SPARROW. *Amphispiza bilineata.*
Only in the desert can one expect to find this handsome sparrow,
known by the white stripes setting off its gray face and black throat.
From Texas to eastern California, north to southern Idaho, the
Black-throated Sparrow has a wide summer range. It withdraws
from northern areas in winter, but in the Southwest it is common
all year. Its nest, built in the base of a dense shrub or cactus, is
often hard to find. Unlike some desert birds, this sparrow does not
do well in settled areas, so it has declined with the growth of cities
in the Southwest.

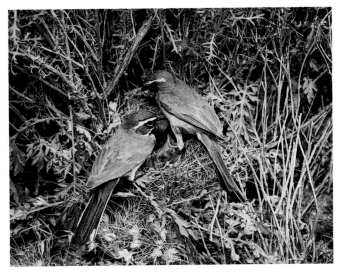

114. HENSLOW'S SPARROW. *Ammodramus henslowii.* A van-
ishing species of eastern meadows is the secretive little Henslow's
Sparrow. This bird seems to work at remaining unnoticed. Even its
song is easy to miss: a short, hard *tsslick*, of barely more than one
syllable. When not singing, the bird stays down in dense grass, flying
only if closely approached. If seen well, it is colorful for a sparrow,
with olive-tinged head contrasting with reddish stripes on its back.
Unfortunately, Henslow's Sparrow has disappeared completely
from some areas and is declining in most parts of its current range.
Loss of habitat, especially meadows of native plants, seems to be
the main problem.

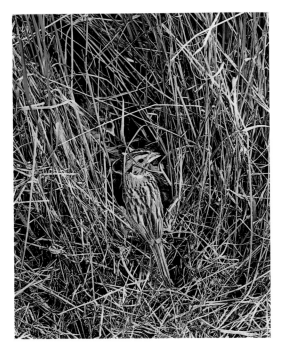

115. CLAY-COLORED SPARROW. *Spizella pallida.* Plain but personable, this sparrow is a bird of the prairie heartland of the continent. In the Dakotas and nearby areas, it can be abundant in summer in open country. From every thicket of wild rose on the prairie, it seems, Clay-colored Sparrows sing their unremarkable but unmistakable song, a series of four long, flat buzzes on one pitch. In autumn the birds migrate south to Texas and Mexico, with only small numbers straying to the Atlantic and Pacific coasts. Recent decades have seen a gradual decline in numbers of Clay-colored Sparrows, for no obvious reasons.

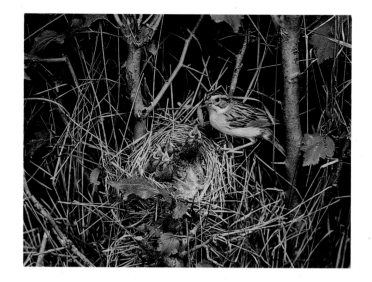

116. WAKULLA SEASIDE SPARROW. *Ammodramus maritimus juncicola.* No other songbird hugs the salt marsh so closely as the Seaside Sparrow. From New England to northeastern Florida, and from western Florida to Texas, it is rarely found more than a few yards away from coastal marshes. Within this restricted range, it has disappeared from many areas following development on the coast. The form shown here, the Wakulla Seaside Sparrow, is limited to a small section of northwestern Florida. Darker than most races, it approaches the appearance of the Dusky Seaside Sparrow of Florida's east coast – a bird that faded to extinction in the 1980s.

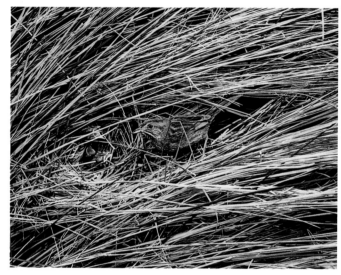

117. SONG SPARROW. *Melospiza melodia.* Many of our native sparrows are delightful singers. The Song Sparrow may not be the most melodious, but it sings with great fervor and zest, a fast song with sharp notes, buzzes, and trills. This sparrow is found almost throughout North America, from overgrown eastern gardens to western marshes, desert riversides, and wild Alaskan islands. Everywhere it favors dense low growth, foraging under the cover of thickets and placing its nest on the ground or in a low shrub. Song Sparrows in general are doing well, but some distinctive local races – especially those in coastal marshes – are threatened by loss of habitat.

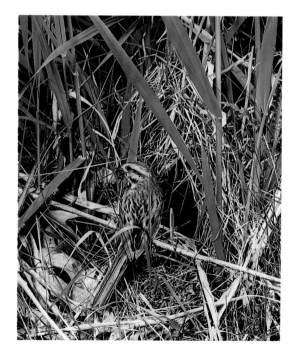

118. SLATE-COLORED JUNCO. *Junco hyemalis hyemalis.* In the dead of winter, snow-covered backyards and parks of the eastern states are enlivened by little flocks of juncos, foraging on the drifts and making cheerful little clicking sounds. Part of the wide-ranging and variable species known as Dark-eyed Junco, the Slate-colored race is the only form nesting across most of northern and eastern Canada, and the only one typically seen in the eastern states. Although it lacks the tones of pink, red, or brown displayed by most of its relatives, the Slate-colored Junco proves how attractive a purely gray-and-white bird can be.

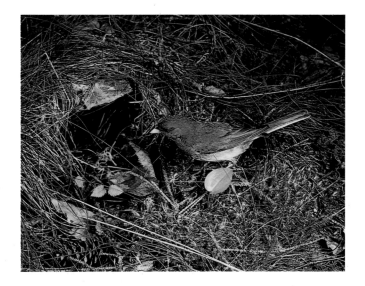

119. GRAY-HEADED JUNCO. *Junco hyemalis caniceps.* The central Rocky Mountains of Colorado and Utah provide a summer home for this junco. It can be separated from other varieties by its combination of gray sides, pale pink bill, and bright reddish-brown back. Like other juncos, it usually nests on the ground, tucking its nest beneath a sheltering shrub, log, or grass clump. During the winter many Gray-headed Juncos move south into the foothills and valleys of the Southwest. On their winter range they mix freely with other races of Dark-eyed Juncos, and several varieties may be observed in the same flock.

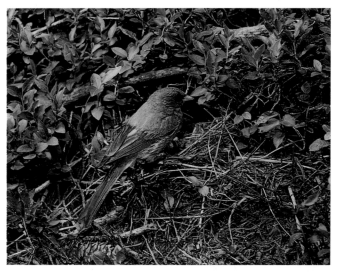

120. GAMBEL'S WHITE-CROWNED SPARROW. *Zonotrichia leucophrys gambelii.* A favorite of field biologists, the White-crowned Sparrow has been studied in the wild in many regions. One reason for the fascination: almost every local population, especially in the West, sings a slightly different song. These "dialects" have inspired years of research into how bird songs evolve. White-crowns also vary in appearance from place to place. The form seen here, Gambel's White-crown, summers mainly in western Canada and Alaska. The feathers around its eyes are pale, not dark, giving it a more innocent expression than the White-crowns nesting in eastern Canada.

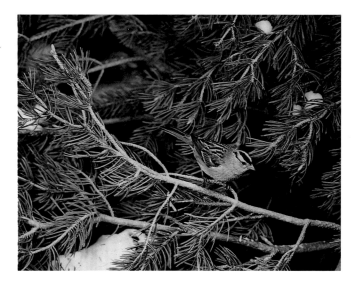

121. RED-WINGED BLACKBIRD. *Agelaius phoeniceus.* In practically every marsh, swamp, and water-filled ditch throughout North America, male Red-winged Blackbirds greet the early spring by perching atop swaying cattails, puffing up their red epaulets, and singing a harsh, nasal *konkareee.* The female Red-wings, streaky and brown like overgrown sparrows, build bulky nests lashed to the reeds or to the stems of bushes at the water's edge. Although wetlands have been drained or destroyed in many parts of our continent, the adaptable Red-winged Blackbirds probably have not suffered from habitat loss as much as most marsh birds.

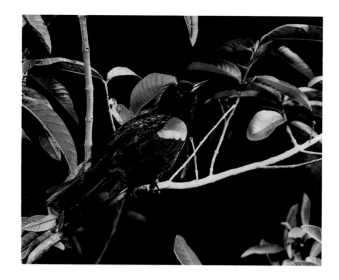

122. SCOTT'S ORIOLE. *Icterus parisorum.* The piping melodies of this oriole are deep and full-toned, a fitting sound to go with the bird's rich yellow-and-black pattern, and with the rugged western hills where it lives. Although it avoids true desert, the Scott's Oriole occurs in summer in other dry habitats of the Southwest, including woods of pinyon pine and juniper, palm groves, or stands of yucca on the grasslands. The yucca plays an important role in its nesting: often, as seen here, the oriole chooses a site among the long leaves of this plant and uses the strong yucca fibers in weaving the nest.

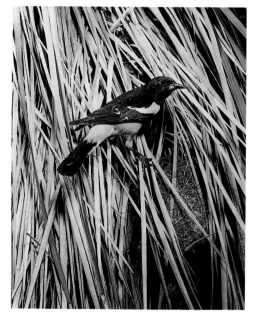

123. BALTIMORE ORIOLE. *Icterus galbula.* Were it not for the songbird named in his honor, few people today would know that the seventeenth-century Lord Baltimore chose orange and black as the heraldic colors for his coat-of-arms. Baltimore Orioles still carry these rich colors over most of eastern North America in summer. They favor groves of deciduous trees, including elms and other shade trees in towns. The typical oriole nest, a hanging, bag-shaped pouch woven of plant fibers, is usually suspended near the end of a slender branch; the young orioles may sway in the breeze, but they are safe from predators.

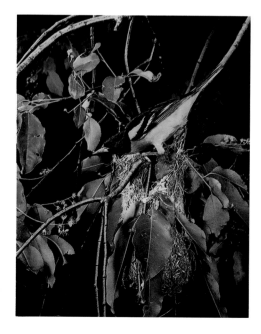

124. PINE SISKIN. *Carduelis pinus.* Although its streaky brown look could suggest a sparrow of some kind, the Pine Siskin is really related to the goldfinches; we could think of it as a goldfinch wearing camouflage. In winter, flocks of siskins come swirling down to feed on the seedheads of weeds in fields or along the edges of woods, making twittering and buzzing calls, flashing hints of yellow in their wings and tails. They will come to backyard bird-feeders stocked with thistle or niger seeds. In summer the Pine Siskins move to conifer groves of the northern forest and western mountains.

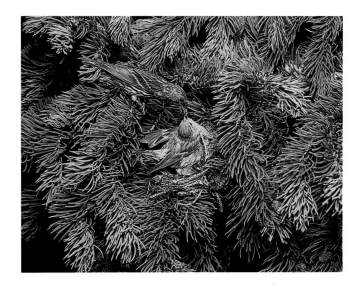

125. LESSER GOLDFINCH. *Carduelis psaltria.* When this tiny finch flies overhead, making soft plaintive or chiming calls, it is known by its up-and-down flight and by the white spots in its wings and tail. Lesser Goldfinches live in warmer regions of the West, from Oregon to Texas, especially along streams through arid country. Their nesting season is surprisingly long: in the Southwest, they may be raising young any time between February and November. The song is a long-running varied twittering. It sounds random at first, but someone who listens closely will find that the goldfinch is imitating dozens of other birds, proving itself a songbird of exceptional skill.

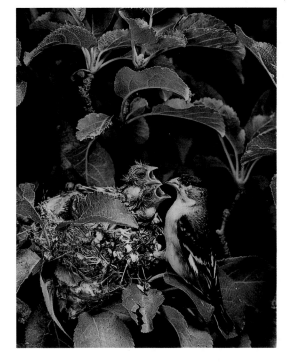

Acknowledgments

ALMOST EVERY SPRING that I can remember, growing up in Santa Fe and into my college years, my father photographed birds. At first he photographed around our house and in the nearby mountains, and when I was little I would spend the day with him while he sat quietly in his jeep watching a nest. Later he traveled all over the country, and I sometimes followed him to more distant places such as southern Arizona and northern Minnesota. His life photographing birds was separate from his life at home. He was not alone, however: he had several friends who were also photographing birds, and they would meet where the birds that interested them were nesting.

Foremost among these friends were Powell and Betty Cottrille, whom I had the pleasure of meeting several times. They became almost a second family to him, and he shared this part of his life with them. The Cottrilles were very important to Eliot, and I was the only member of his family who knew them – I don't think they and my mother ever met – he would talk to me about them. There were friendly competitions – Betty and Eliot would argue about who made the best apple pie, but Eliot always acknowledged that Powell was better at finding nests.

This book is the result of a lifetime of work, but it is also the result of the long relationship Eliot had with the Cottrilles. It is fitting, therefore, that their significant contribution to this work be acknowledged here. In the late 1930s Eliot received special help in learning to find nesting birds from his brother-in-law Lawrence Kilham. There were others whose contributions Eliot would want to acknowledge, including Edward M. Brigham, Jr., William Dyer, and Lawrence H. Walkinshaw, who helped Eliot in the earlier years of this project.

Stephen Porter
April 1996

DESIGNED BY
ELEANOR CAPONIGRO.
PRINTED AND BOUND BY
ARNOLDO MONDADORI,
EDITORE, S.P.A.,
VERONA, ITALY.